Hi-Fi Color
for comics

DIGITAL TECHNIQUES
FOR PROFESSIONAL RESULTS

Brian & Kristy Miller

IMPACT
CINCINNATI, OHIO
www.impact-books.com

Other fine IMPACT books are available from your local bookstore, art supply store or direct from the publisher at www.fwpublications.com.

12 11 10 09 08 5 4 3 2 1

DISTRIBUTED IN CANADA BY FRASER DIRECT
100 Armstrong Avenue
Georgetown, ON, Canada L7G 5S4
Tel: (905) 877-4411

DISTRIBUTED IN THE U.K. AND EUROPE BY DAVID & CHARLES
Brunel House, Newton Abbot, Devon, TQ12 4PU, England
Tel: (+44) 1626 323200, Fax: (+44) 1626 323319
Email: postmaster@davidandcharles.co.uk

DISTRIBUTED IN AUSTRALIA BY CAPRICORN LINK
P.O. Box 704, S. Windsor NSW, 2756 Australia
Tel: (02) 4577-3555

Library of Congress Cataloging in Publication Data
Miller, Brian G. (Brian Glen), 1973-
 Hi-Fi color for comics : digital techniques for professional results / Brian and Kristy Miller.
 p. cm.
 Includes index.
 ISBN-13: 978-1-58180-992-3
 1. Color computer graphics. 2. Adobe Photoshop. 3. Comic books, strips, etc.--Illustrations. I. Miller, Kristy. II. Title.
 T385.M5433 2008
 741.5'1--dc22
 2007034620

Edited by Amy Jeynes
Editorial consultation by Buddy Scalera
Production edited by Sarah Laichas
Designed by Guy Kelly
Production coordinated by Matt Wagner

Acknowledgments

The authors would like to acknowledge the following people and companies who graciously contributed to this book: Shelly Bond, Paige Braddock, David Bryant, John Byrne, Gary Carlson, Joe Casey, Joe Corroney, Ed Dukeshire, Kevin Geiss, Chad Hardin, Phil Hester, Dan Jurgens, Steve Lightle, Casey Maloney, Jim McLauchlin, Terry Moore, Kel Nuttall, Joe Quesada, Frank Quitely, Humberto Ramos, Sherwin Schwartzrock, Gail Simone, Matt Wagner, Mike Worley and Dustin Yee.

The authors would also like to thank our friends at DC Comics, Dark Horse Comics, Disney Adventures, Dreamworks/Titan, Devil's Due Publishing, Graphic Universe, IDW Publishing, Image Comics, King Features, Lucasfilm Ltd., Marvel Comics, Top Cow Productions, United Media and Wizard Entertainment for your never-ending support.

Last, we would like to thank our editor, Amy Jeynes, for being patient while we juggled coloring and writing.

Dedication

This book is dedicated to our friends, our families, and all the interns, flatters and colorists who have worked with us over the years. Hi-Fi would not be what it is today without the hard work and support of so many wonderful people. This is for you.

Metric Conversion Chart

To convert	to	multiply by
Inches	Centimeters	2.54
Centimeters	Inches	0.4
Feet	Centimeters	30.5
Centimeters	Feet	0.03
Yards	Meters	0.9
Meters	Yards	1.1

About the Authors

Even as a child, **Brian Miller** loved to color and paint. After earning straight smiley faces in preschool art, he tested into a grade-school gifted program known as Bright Ideas, where he quickly earned the nickname "Marker-Happy" because of his enthusiasm for that medium (and evidenced by the constant stains on his hands and clothing).

As a teenager, Brian discovered both Macintosh computers and comics and experimented with coloring comic art. He picked up real-world design experience working part-time for magazine publishers and printing companies while studying art at Southwest Missouri State University. There, he also met Kristy.

Kristy Miller has degrees in antiquities and secondary education from Southwest Missouri State, as well as a master's in museum studies from the University of Kansas. After working and living in various countries throughout the world, Kristy began teaching middle school history and Macintosh computers while Brian worked at an advertising agency. Brian continued to color comics on the side using various pen names until, in 1998, he walked away from his art director position to start Hi-Fi Colour Design with Kristy and a group of talented creators. After one too many harsh Missouri winters, Brian and Kristy moved Hi-Fi to Arizona. There, Kristy worked at a museum as Director of Education until she left her position in 2002 to help Brian run Hi-Fi Colour Design full-time.

Kristy handles the day-to-day, non-artistic sides of Hi-Fi. For fun, she teaches anthropology and history at a community college. Brian enjoys coloring and creating fully painted covers and pin-ups for comics, books and magazine covers. In this book, *Hi-Fi Color for Comics*, Brian is sharing his coloring secrets with the world for the first time. He hopes the book will be an inspiration to artists young and old.

Table of Contents

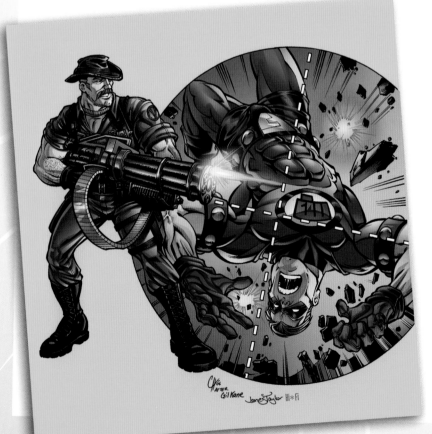

Blast Into Action
This gun blast in *Fist of Justice* adds a sense of action and motion to the gun, and it helps the foreground figure come forward as it pushes the scope image into the background.

foreword

by Shelly Bond, VERTIGO Group Editor

I'm a purist, which means that I'm not impressed by book introductions that spout pithy one-liners ripped from the *New York Times* film reviews, nor ones that erupt with labored phrases from philosophy majors who dual-minored in French and medieval poetry.

I'm an editor—I like 'em lean and mean.

So when Brian Miller asked me to write a foreword for this book, my first question was: What's the word count? Editors aren't often asked to write introductions because, I'm told, we're not writers and we're not that interesting.

Ah, good—you're still reading. In an age when so many colorists feel the need to use every color filter, lighting effect and modern convenience, Brian Miller does the unthinkable: He starts with my two favorite colors—black and white— and, apparently by channeling Andy Warhol, Peter Greenaway and Ian Curtis, he turns pages into pure, adulterated pop. He creates motion and ambiance with his seasoned choices of hues and hard-edged shadows, bringing the penciller's and inker's already amazing efforts (hey, we're talking about titles I edit!) to a new level of artistry.

But I'm just an editor from the school of slice-and-dice. All I really need to say is that working with Brian Miller is a cakewalk. He knows what I like, whether it's high contrast with deep knockouts or monochrome in one color temperature (not two!). He hits his deadlines, and he's without a doubt one of the finest colorists to make a dent in the art scene of the twenty-first century. But don't take my word for it. See (and read) for yourself.

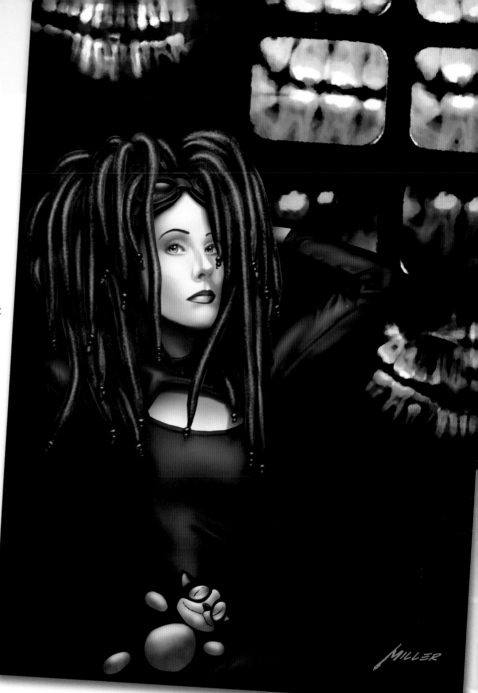

NIGHTMARES OF TEETH
Art and color by Brian Miller

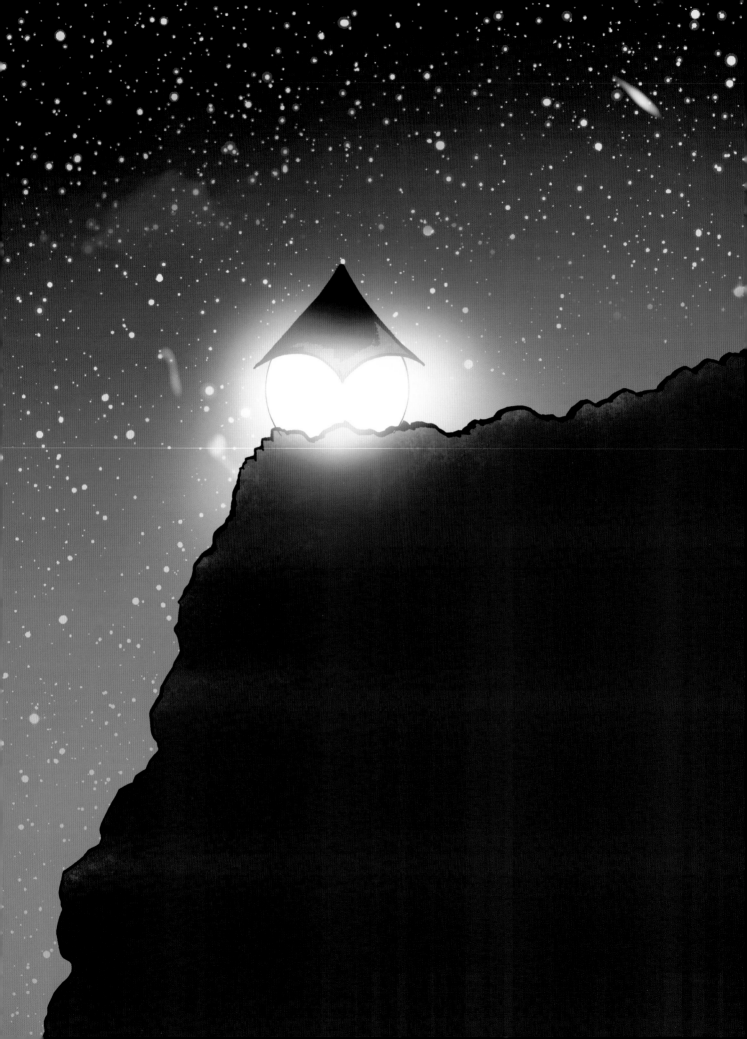

Introduction
by Terry Moore, creator, *Strangers in Paradise*

As a cartoonist, I can't begin to fathom what goes on in the mind of a painter. Where I see lines and shapes, painters see light and contrast. Where I see two-dimensional opportunities, painters see 3-D forms that stand out from one another due to some weirdo laws of physics concerning the time-space relationship. This, in a nutshell, is why I am not allowed to play with a box of crayons, and why people like Brian Miller are bringing crude drawings by artists like myself to life with computer coloring.

You think I'm exaggerating? Once I gave Brian nothing but a drawing with nine lines on it and said, "Here, fix it. Paint it up and fill it with texture." Brian did not punch me out, to which he had every right, but instead took the drawing of a round pagoda atop a mountain ridge and painted a magical world around it. The pagoda came to life, emanating a warm glow that called to the starry sky above and earthly mysteries hid in the rocky cliff below. It was one of the most beautiful covers in the *Strangers In Paradise* series. See, that's the difference between a cartoonist and a painter . . . the cartoonist implies; the painter delivers.

The fact that Brian performs this magic through a lifeless assembly of electronics is just all the more confounding to me, and if you're reading this book it must be something of a challenge to you as well. If so, you've come to the right place, my friend. Brian has spent years developing his skills and techniques, and now some wise publisher has finally gotten him to slow down long enough to share with the class.

This is a big deal because Brian is the consummate professional. By that I mean that not only can he do the great work, he can also explain it. He knows color, he knows computers, he knows printing and he knows the limits and capabilities of all these stages. He also knows how to work with editors and big companies with tight schedules and the lone creative flakes that come to him for comic book salvation. In short, he knows the big picture. He knows his job, my job, the editor's job, even the Photoshop developer's job. That's why Brian is the only colorist allowed to go near my work. I don't mind him sharing a few secrets with you now, but come the first of the month I need him back, okay? We have comics to make.

Original line-art drawing by
Terry Moore

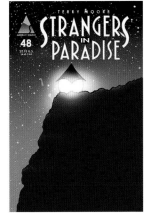

As printed with indicia

OPPOSITE: COVER IMAGE, *STRANGERS IN PARADISE* VOL. 3 #48
Art by Terry Moore
Color by Hi-Fi

Guide to the Book

There's a lot of instruction and great artwork packed into this book and its accompanying CD-ROM. Here are a few explanations and signposts to help you navigate.

Lessons

- We recommend that you work the step-by-step lessons in order from start to finish. Each lesson builds on skills or artwork developed in earlier lessons.
- The lessons in this book use Adobe Photoshop screen shots and commands, but the techniques are applicable to most current image-editing programs (see "Software," pages 12–14).
- If you know a way to access a command that's different from the one we show, feel free to use it. Most software packages make commands accessible from multiple places.
- Using your knowledge of the software, you might come up with entirely different techniques for achieving the same visual results as we do. We encourage you to think creatively and have fun as you do the lessons.

Chapter Homework

- Each chapter ends with one or more fun homework assignments designed to let you practice your new skills. You can find the answers to homework questions at www.hifidesign.com in the *Hi-Fi Color for Comics* Members Area.

Other Resources

- The glossary and index (at the back of the book) will help you whenever you return to this book and want to find a term or concept quickly.

The CD-ROM

- The CD-ROM contains Photoshop brushes, palettes and actions, plus practice artwork that can be used with any graphics software. If you're using Photoshop, there are some presets and settings you should install before you begin the lessons in the book. (See pages 10–11 for instructions.)

Sample Sidebars

Vital information in the book is broken out into sidebars so you can find it easily and learn it fast. (See the sample sidebars below.)

Everyone skips around in books at times, so we try to help you stay oriented by means of Review and Preview sidebars. Still, you'll benefit the most from this book if you read it from front to back.

Pro Tip

Psst . . . Hey! Yeah, you. Wanna know a secret? Sure you do. Pro Tips are the hints and techniques we've learned through our years of coloring comics.

LIFE SAVER

The tips in these Life Savers will save you time or prevent your artistic ship from sinking in the whirlpool of a time-consuming mistake. If we hadn't made mistakes along the way, we wouldn't know to warn you!

Review:

Lets you know what page to flip to if you need to refresh your memory on a topic that was covered earlier.

Preview:

Tells you that a topic will be covered (or covered in greater depth) later in the book.

Tells you how to use Photoshop's keyboard commands to bypass menus and get tasks done faster. If the command used in the Windows version differs from that on the Macintosh, both are given.

VOCABULARY:

Terms you need to know, defined and explained.

Hi-Five

Contains words of encouragement or reassurance at key points where you might need it. We're impressed that you've decided to embark on this educational journey. It will be challenging at times, but we're sure it will be incredibly fulfilling, too.

What's on the CD-ROM

This book comes with a bonus CD-ROM loaded with goodies to help get you coloring faster and better.

Photoshop-Specific Goodies
- Palettes
- Brushes
- Scripts
- Actions

More Stuff
- Effects
- Hi-Fi Helpers for subjects such as skies, water and sand
- Practice artwork
- Examples to study
- Sample color separations with trapping
- All the files you will need for the step-by-step lessons in this book

Custom brushes

Hi-Fi Helpers

Photoshop scripts and actions

Useful Files and Photoshop Tools
Hi-Fi's Photoshop scripts and actions automate the technical tasks so nothing distracts you from being creative. Custom brushes, color palettes and reusable art help you get professional results faster.

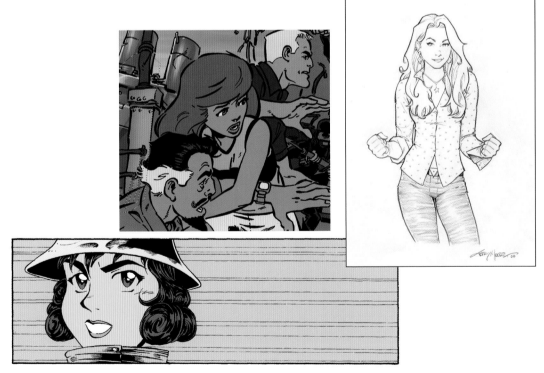

Art to Practice Coloring
On the CD-ROM, you'll find dynamic, professionally drawn comic art that you can practice coloring.

How to Install the Hi-Fi Presets

Before you start the lessons in this book, install the Hi-Fi Photoshop Presets from the CD-ROM that comes with this book.

1 Quit the Photoshop application. Navigate to the location of the Photoshop application on your hard drive. Inside the Photoshop folder is a folder called "Presets." Open that, and in it you will find folders named "Brushes," "Color Swatches," "Photoshop Actions" and "Scripts."

2 Insert the Hi-Fi CD-ROM into your drive. On it, you will find a folder named "For Photoshop." Inside is a folder called "Photoshop Presets" containing the subfolders "Hi-Fi Brushes," "Hi-Fi Color Swatches," "Hi-Fi Photoshop Actions" and "Hi-Fi Scripts."

Copy the items in the above folders to the corresponding folders on your hard drive which you found in step 1.

3 Launch Photoshop. To verify installation of your Hi-Fi presets, open the Brushes, Actions and Swatches palettes (Window menu > Brushes; Window menu > Actions; and Window menu > Swatches).

If you do not see the Hi-Fi presets in each of those palettes, you may need to load them. To do that, choose "Load Actions . . ." from the drop-down menu in the Brushes palette. When the dialog box appears, navigate to and select the files on the CD-ROM that you want to load. Repeat for the Swatches and Actions palettes.

4 From within Photoshop, choose Edit menu > Color Settings. In the dialog box that appears, click Load. Navigate to the CD-ROM, open the folder named "For Photoshop," and then open the folder "Hi-Fi Color Settings." Load the file named "Hi-Fi Default Color Settings.csf." This file contains a CMYK profile and settings compatible with the Photoshop "Hi-Fi Step 3" script you will use for color separations later in the book.

Whether you are using Photoshop for print or web, you will achieve excellent results using Hi-Fi's settings, though it is not necessary to install them for web-only coloring.

Usage Guidelines for Practice Files

Many comic-industry professionals have graciously allowed their art to be included on the CD-ROM for you to practice coloring. Please respect their copyrights by not redistributing the artwork in any form, except as follows.

We invite you join the *Hi-Fi Color for Comics* user forum at www.hifidesign.com, where you can share your practice images with other up-and-coming colorists and receive critiques, feedback and assistance from the user community. Please do not post practice artwork online except in the forum at www.hifidesign.com.

Thanks for respecting the artists' ownership and copyrights!

Software

To unlock all your creativity, you need some image-editing software. Most pro comic colorists use Adobe Photoshop. All the examples in this book were done with Photoshop, and the step-by-step lessons are based on Photoshop. However, there are many other good options available at various price points. For a sampling, see the Software Feature Comparison Chart on page 14.

Even if you're not using Photoshop, your coloring results can still be very similar to ours, or even the same. And of course, the concepts involved in coloring—such as making effective color choices, creating cuts and adding highlights—are essentially the same no matter what software you use.

Selection and Painting Tools

Our lessons make heavy use of Photoshop's Lasso, Magic Wand, Brush and Gradient tools. Most other image-editing packages have tools comparable to these, even if they have different names or function in a slightly different manner.

Layers and Channels

Most modern image-editing applications include a Layers feature. Layers are like sheets of transparent plastic stacked one upon another. Imagine you have a painting as your background layer, and you add your favorite comic book character on a new layer. You can't see the background under the character, but it's still there, and the character can be moved and manipulated independently of the background image.

Some software packages also have

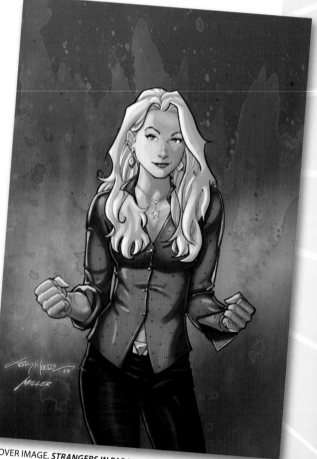

COVER IMAGE, *STRANGERS IN PARADISE* VOL. 3 #85
Art by Terry Moore
Color by Brian Miller

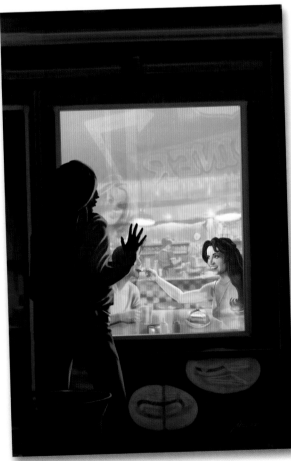

BACK COVER IMAGE, *STRANGERS IN PARADISE* VOL. 3 #83
Art and color by Brian Miller

a feature called "Channels." Channels are the digital equivalent of some of the darkroom techniques used by traditional photographers. Channels allow you to store selections and isolate certain parts of images. Channels generally contain 256 shades of gray, but no color information. If your favorite image editing software does not offer Channels, don't worry; nearly everything we do with Channels in this book can be achieved using Layers or other tools.

Drivers and Other Software

Scanners, printers and grapics tablets have drivers and other software associated with them. Make sure that your software is updated to the most current version that is compatible with your operating system and image-editing software. Often you can download updates from the manufacturer's website.

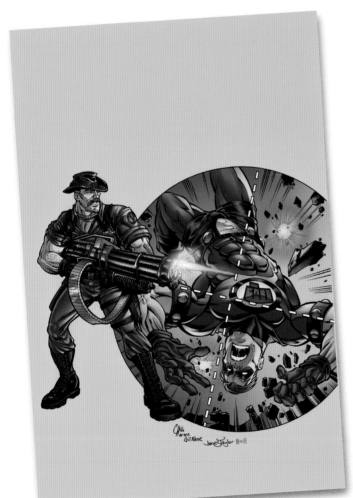

FROM *DIGITAL WEBBING PRESENTS* #29B: *THE FIST OF JUSTICE*
Art by Chad Hardin
Color by Hi-Fi

Fist of Justice copyright © 2006 Mike Imboden and Ed Dukeshire

COVER IMAGE, *STRANGERS IN PARADISE* VOL. 3 #82
Art by Terry Moore
Color by Hi-Fi

Tools + Skills + Vision = Style
Each image on this spread was colored by Hi-Fi using Adobe Photoshop, a very capable program and the one most pro colorists use. If having a certain software tool were the most important thing, though, then you'd expect every piece of art colored with Photoshop to be pretty much the same in style . . . which, as you can see here, is far from the case.

Software Feature Comparison Chart

This is a sampling of available image-editing software. Lists of tools and features are not intended to be complete. New software versions may have been released since publication; consult the publishers' websites for the latest information.

Package	Relative Cost	CMYK support[1]	Layers[2]	Channels[3]	TWAIN-aware[4]	Comments/other features relevant to colorists
Adobe Photoshop CS3 (www.adobe.com)	$$$	Yes	Yes	Yes	Yes	Full-featured and powerful; the standard pro-level image-editing package, especially for those preparing artwork for print.
Corel Painter X (www.corel.com)	$$	Yes	Yes	Yes	Yes	Wide array of brushes, brush controls and textures.
Adobe Photoshop Elements (www.adobe.com)	$	No	Yes	No	Yes	Has many of the same features as full Photoshop (though not always with the same range of controls). Doesn't have pro essentials such as batch automation and CMYK support.
Corel Paint Shop Pro Photo XI (www.corel.com)	$	Yes	Yes	Yes	Yes	Many photo-editing and management tools; some painting, drawing and gradient features. Windows only; no Macintosh version.
GIMP 2.2 series (www.gimp.org)	Freeware	No	Yes	Yes	Yes	Extensive painting, selection and gradient tools. Many tools similar to those in Photoshop.

[1]CMYK support is necessary if you're doing comics for print. We'll get deeper into CMYK in chapter six.

[2]Layers allow you to color within a layer without affecting art on other layers. Essential for many, though not all, effects and techniques.

[3]Implementation of channels varies. A "Yes" in this column means the package offers some form of channel that can be used to separate the line art from the coloring. We'll talk more about Channels on page 30.

[4]TWAIN is a common interface standard for getting images from a scanner or camera directly into image-editing software. See page 16 for more information.

Organizing Your files

Colorists are responsible for a lot of files. For every comic book page you color, you'll have multiple files representing various stages of the coloring process. It's important to use a file organization system that minimizes your chances of saving over a file or making some other mistake that costs you a day's work.

With Hi-Fi's simple system for file naming and organization, you'll always know what's what and where to find it.

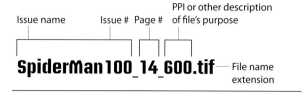

Issue name Issue # Page # PPI or other description of file's purpose

SpiderMan100_14_600.tif — File name extension

Use a File-Naming Convention

If you consistently use a file naming convention such as this one, you'll always know what a file is for even if it should get into the wrong folder. Also, this method helps you avoid the confusion and losses that can result from duplicate file names.

1. Project Folder
Name this folder with the title and issue number you're coloring.

2. Line-Art Folder
Contains line art to be colored.

SpiderMan100_14_600.tif

Some file-trafficking computer systems used by publishers have trouble with spaces or special characters in file names, so use hyphens (-) or underscores (_) instead. This problem is less common now than it was a few years ago, but it doesn't take any extra work to use an underscore and be safe.

4. RGB PSDs Folder
Contains working versions of your color render files.

SpiderMan100_14_400_A.psd
SpiderMan100_14_400_B.psd
SpiderMan100_14_400_C.psd

If you want to save versions of your files as you work on them, append a letter to each version's file name to make it obvious which version is the newest. Once your project is approved and printed, decide whether you want to archive all of these working files or just the final version of each page.

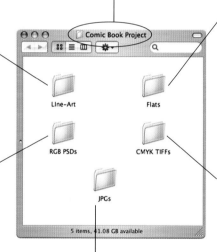

3. Flats Folder
Pages with just the flat color fills added.

SpiderMan100_14_Flats.tif

Keeping the flats separate from the rest of your coloring makes it easy to go back to the flats if you need to.

5. CMYK TIFFs Folder
Color separations.

SpiderMan100_14_400_CMYK.tif

Append "_CMYK" to the file names so there is no doubt they are final print files.

6. JPGs Folder
Contains 72ppi RGB JPGs of your CMYK TIFF files.

SpiderMan100_14_400_CMYK.jpg

Every time you make a new CMYK TIFF, create a new RGB JPG that you can email if the penciller needs to double-check your work or an editor needs to see changes ASAP. Since you're making these review JPGs from CMYK TIFF files, keep the "_CMYK" in the file name even though the JPG should be stored as an RGB file. That way you know the JPG that you and your editor are looking at came from the CMYK print file.

Keep Only One Print-Ready File Per Page

Make it a rule that for each comic page you color, you allow only one print-ready CMYK TIFF to exist. In other words, every time you revise the page, replace the CMYK TIFF. This ensures you'll never send out the wrong version. The same goes for the low-res RGB JPGs in the JPGs folder, which you might send out for others to review.

Hardware

The following is your jargon-free (as much as possible) guide to choosing computer equipment for digital coloring.

Computer

Most new computers today meet the basic parameters for current image-editing software. Check the system requirements for the software you plan to buy (usually printed on the box) before you buy a computer.

If you already have a computer and you use it to play games, watch video clips online, or use the Internet, chances are it's capable of running current image-editing software. Maybe all you need to do is add some RAM or another hard drive.

Monitor

You want a monitor that shows decent color and offers an adequate range of adjustments. Any name-brand monitor should allow you to set the gamma, white point, brightness and contrast either through the operating system or with buttons on the monitor itself. (See the Pro Tip on the facing page for which monitor settings we recommend and why.)

Scanner

Most name-brand scanner models in the $99–$199 price range will meet your needs. Still, be sure the scanner you buy has the following capabilities.

Since line art for comics is scanned at 600dpi, make sure the scanner you purchase has a minimum optical resolution of 600 × 600dpi.

Also look for a minimum of 24-bit color recognition. Even if you do not scan in color often, you will need to scan grayscale pencil images. A 24-bit color scanner divides its 24 bits among its three color processors—red, green and blue—at 8 bits each. The standard for a grayscale image is 256 shades of gray, which is 8 bits of "color" data in digital-art terms. When you scan a grayscale file, only one of the three RGB processors is used to capture the grayscale data. One-third of a 24-bit processor is 8, so you need a 24-bit scanner to capture 8-bit grayscale. Anything less and your scans of pencilled art might be missing some dynamic lights and shadows.

Most scanners come with both a stand-alone scanning application and a TWAIN-compliant scanner driver. If your image-editing software can use the TWAIN driver, you'll be able to initiate scanning directly from your software. If your software isn't TWAIN-aware, you'll need to scan and save from the stand-alone scanning application and then import the image into your software. This is a little less convenient, but still works fine.

Printer

There are plenty of inexpensive color printers on the market; the challenge is figuring out which one to buy. Inkjet printers cost much less up front than color laser printers, but if you're printing a lot, the cost of ink cartridges adds up fast. Color laser printers cost at least ten times as much as the cheapest inkjets, but you might need to replace the

LIFE SAVER

Don't Go Broke!

You're better off buying a computer you can afford and upgrading every two to three years, rather than spending your last dime on the biggest, baddest computer out there and then being stuck with it until the end of time.

toner cartridge only once a year. You'll have to decide which solution works better for you, balancing your available cash against the amount of printing you anticipate doing.

Don't count on any desktop printer to show you 100 percent accurately how your color files will look when printed on a commercial printing press. (That's because the color systems used in each case are completely different; more on that in chapter six.) But a printer is still useful and necessary for reviewing the detail and accuracy of your coloring.

Graphics Tablet

You may already have a computer, monitor, printer and even a scanner, but you may not have a drawing tablet (sometimes referred to as a Wacom pad, since Wacom is the most popular brand of drawing tablet). The drawing tablet replaces your mouse and mousepad with a mousepad-sized tablet, a cordless mouse and a cordless drawing pen (or stylus). A graphics tablet allows you to paint and draw directly into the computer just as if you were using a real paintbrush, pencil or other art tool. The pen can even act as a virtual art knife with which you can select elements to be moved, manipulated, or removed completely from a digital composition.

While you can always use your computer's mouse for all the instructions in this book, a graphics tablet can make coloring faster and easier.

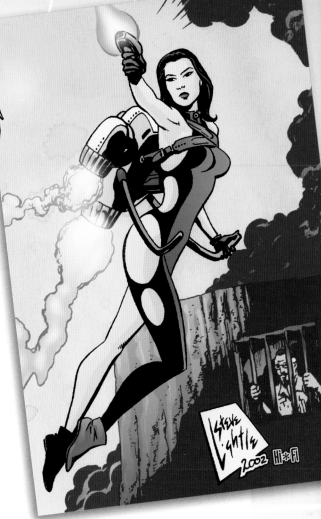

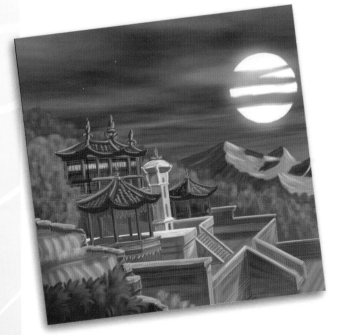

ART ON PAGES 16–17 FROM *THE TERRIFYING TALES OF TOMMI TREK*
Art by Mike Worley and Steve Lightle
Color by Hi-Fi

Pro Tip — Monitor Settings

Any time you distribute your digital art, you surrender control of the viewing environment. Art you publish on the Web or put on a CD-ROM might be seen on a Mac, a PC, a Unix machine or even a television.

To ensure that the colors that look good on your monitor will look decent on just about any other platform, use the monitor settings shown below. These settings will show you color within about 90 percent of what you would see on any of the systems mentioned above, and they will give you a very good idea of what your artwork will look like when printed.

Gamma: 2.2
White point: D65
Contrast: 100%
Brightness: 50%

Some people invest in additional color calibration hardware and software to make the color on the monitor as close as possible to the printed result. Most freelance colorists would consider this overkill.

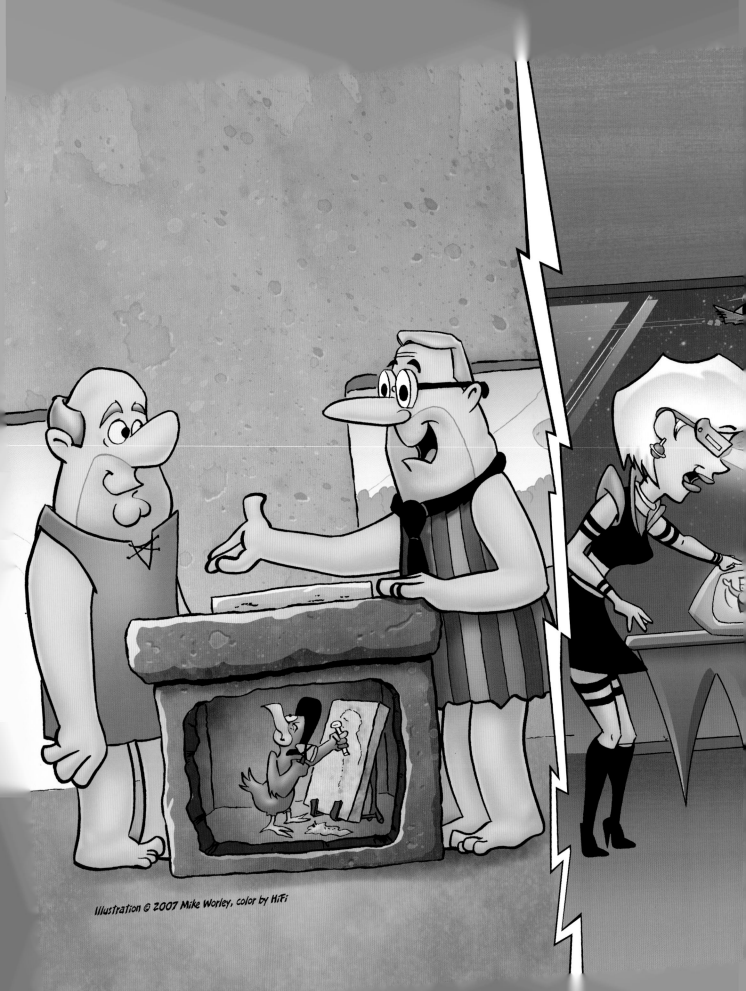

Scanning and Setting Up the Page

Since the dawn of time, humans have been possessed by the desire to share their experiences with others. In cave paintings, hieroglyphics, fables, epics, plays, novels and, eventually, comic books, people have recorded their stories of wit and wisdom, romance and terror to be enjoyed by fans of good storytelling.

Throughout history, technology has periodically changed the ways we tell our stories. Just as Gutenberg's press did in 1450, desktop computers and the desktop printing revolution have enabled greater numbers of people to express themselves to larger and larger audiences.

With all the technology we enjoy today, some find it difficult to believe that most comic book artwork is still drawn by hand, with pencil and paper. So, the question facing the would-be computer colorist is: "How do I get the art into the computer?"

The optical scanner is currently still the best way to capture an image and convert it to digital format. Scanners have been around for so long with so few changes, you might feel downright Stone Age as you lay your artwork on the scanner bed and wait while the scan head slowly traverses the page. But until someone comes up with an instantaneous image-zapper device, the scanner will remain your best friend.

In this chapter you will learn how to scan oversized comic book artwork in two pieces and merge those two pieces back into one image using your image-editing software. In the process, you'll get to know Layers, layer opacity and the Crop tool. Once you have your perfect scan, we'll show you how to use Hi-Fi's special Photoshop script to prepare the page for coloring.

STONE AGE MEETS SPACE AGE
Art by Mike Worley
Color by Hi-Fi

canning Oversized Art

a perfect world, giant flatbed scanners would be available to everyone at reasonable prices. In the real world, the majority of economically priced scanners will scan an area 8.5" × 11" (2cm × 28cm). Most comic book artwork is drawn on art board measuring 11" × 17" (28cm × 43cm). So most of us are faced with the question of how to get oversized art into our computers.

The solution is to scan the artwork in two pieces and "stitch" the two pieces together. Here's how it's done.

Review:

Buying a Scanner
See page 16 for the features to look for when choosing a scanner.

1 Align the Top Half on the Scanner Bed
Align one long edge of the art board along the top edge of the scanner bed. Align the left edge of the art along the left edge of the bed.

2 Mark the Near Edge
Mark the edge of the art closest to you with a small piece of artist's tape or other low-tack tape. (You'll see why in a minute.)

3 Begin Scanning
Launch Photoshop and choose File menu > Import > Scan to bring up your scanner's dialog box. (If your image-editing software is not TWAIN-compliant or if your scanner didn't come with a TWAIN driver, launch the software that came with your scanner instead.)

On screen, you will find options for scanning a variety of media types at different resolutions. If you're scanning inked art, choose Black & White, 600dpi. For pencilled artwork, choose Grayscale, 300dpi.

If your scanner software has an option for scan size, set it to 100%.

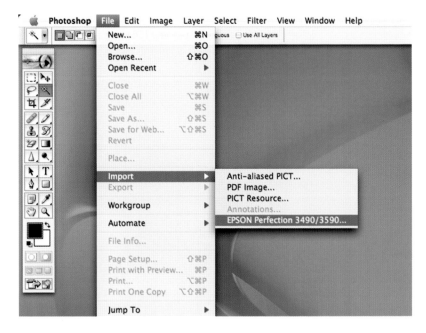

4 Do a Preview

First, set the scanning area to be as large as possible. (In Photoshop, you do that by dragging the edges of a box.)

Whether you're using Photoshop or your scanner's software, there should be two main functions: Preview and Scan. Click Preview. The scanner will do a quick, rough scan. If the preview is crooked, reposition the art on the scanner bed and do another preview.

Once you are satisfied with the preview, click Scan. The scanner will capture the first half of the artwork and give you the image in a new document.

Pro Tip — Scanner Settings

Use the following settings when scanning comic art for coloring:

- Inked art (line art): 600dpi, Black & White, 100% size
- Pencilled art: 300dpi, Grayscale, 100% size

You might be wondering why you shouldn't just scan your 11" × 17" (28cm × 43cm) line art at a percentage of reduction so that you end up with a scan at final printed size. The reason is that your scanner driver probably can't scale (resize) the image as well as Photoshop and most other image editors can. It's tough to match the amount of effort that publishers of graphics software have put into perfecting their scaling algorithms.

5 Scan the Other Half of the Art

Repeat steps 1 through 4 to scan the other half of your artwork, except this time, align the right edge of the art along the right edge of the bed. Remember that piece of tape from step 2? When scanning the second half of the art, be sure to keep that taped edge closest to you. This will make it much easier to align the two scans into one image later.

Preview: Image Resolution

In chapter six, we'll get into the technical reasons behind the recommended scanner settings. For now, we just want you to focus on the mechanics of scanning art into the computer.

Stitching Two Scans Together

Anytime you scan art in two halves and attempt to stitch them together, the seam isn't going to be absolutely perfect. Maybe the edges of the art board aren't perfectly straight, or you didn't lay the board on the scanner bed at precisely the same angle both times. Whatever the cause, you will often find that the two halves can't be made to line up perfectly all the way across.

Here you'll learn a trick for using feathering to disguise stitching imperfections.

1 Rotate the Scans If Needed
In the previous lesson, you scanned an 11" × 17" (28cm × 43cm) piece of artwork in two halves. Open the two halves in Photoshop. If the artwork is sideways, fix it by choosing Image menu > Rotate Canvas. Rotate the image either 90° CW (clockwise) or 90° CCW (counterclockwise) so that it is right-side up.

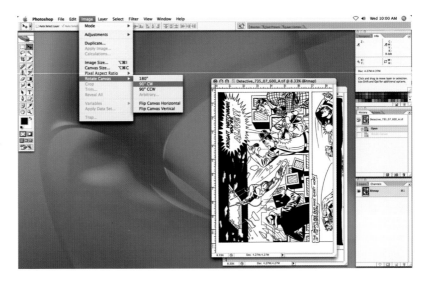

2 Add Canvas to the Top-Half
We're going to start with the document that contains the top-half of the page. Click that one to make it the active document.

Select Image menu > Canvas Size. Change the height dimension to 17 inches (43cm), then click the top center square of the "Anchor" diagram so that the extra white space will be added to the bottom of the existing image area. (This white space is where you'll put the bottom-half of the image to make one complete comic book page.)

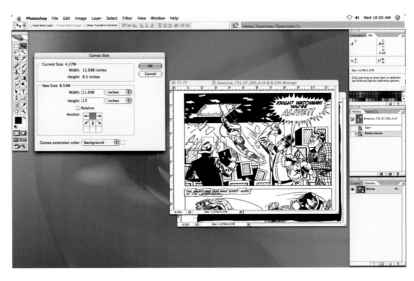

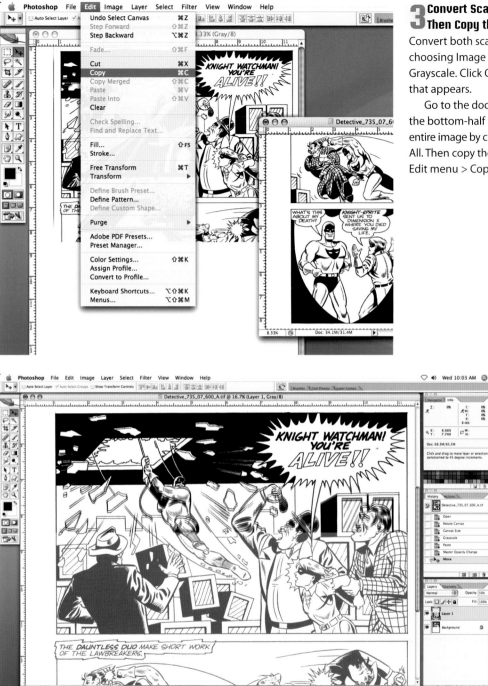

3 Convert Scans to Grayscale, Then Copy the Bottom-Half

Convert both scans to grayscale by choosing Image menu > Mode > Grayscale. Click OK on the dialog box that appears.

Go to the document that contains the bottom-half of the page. Select the entire image by choosing Select menu > All. Then copy the image by choosing Edit menu > Copy.

4 Paste In the Bottom-Half, Then Align

Go to the top-half file, then choose Edit > Paste to paste in the lower half. Now both halves of your comic page are in the same file. In the Layers palette, set Layer 1 to 50% opacity. This will allow you to partially see through that layer. Select the Move tool (the black arrow), then drag the bottom-half image to approximately the correct position.

Choose View > Actual Pixels so that you're seeing the maximum amount of detail. Scroll (or drag with the Hand tool) to locate the area where the two layers overlap. Use the up and down arrows on your keyboard to fine-tune the position of the layer containing the bottom-half of the image until the alignment of the layers is as nearly perfect as possible.

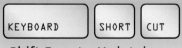

KEYBOARD SHORT CUT

Shift-Drag to Maintain Alignment

Hold down the Shift key while dragging an object, and you can drag it in a straight line vertically, horizontally or at a 45° angle.

Preview:

Layers

In step 4, don't worry if the half you pasted looks like it is covering up part of the other half. Photoshop automatically puts pasted art in a new layer so that you can move it around and fine-tune its placement before you commit. We'll get deeper into the subject of Layers in chapter three.

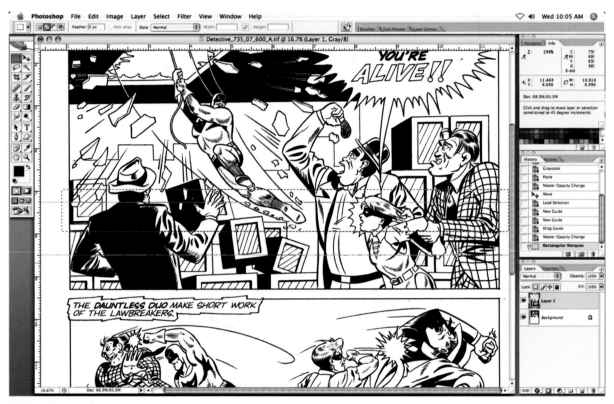

5 Feather to Disguise the Seam

Select the Marquee tool and set its Feather option to 6 pixels. Within the area where the two scans overlap, look up and down for the level where the alignment is best—where the fewest misalignments occur.

Verify that Layer 1 (the bottom-half image) is still the active layer; it should be highlighted in the Layers palette as shown. Now, use the Marquee tool to make a selection around the top edge of the bottom-half image. The selection should start above the bottom-half image and extend down roughly to where the alignment of the two layers is best. Delete the contents of the selection by choosing Edit menu > Clear, then choose Select menu > Deselect to discard the selection.

Now set the opacity of Layer 1 back to 100%. Look closely where the two scans meet. The top edge of the bottom-half image is now feathered, which should disguise any imperfections in alignment between the top and bottom scans.

VOCABULARY:

Feathering

Feathering is like vignetting; it fades the selection from full-strength down to nothing. The value you set for Feather is the width, in pixels, of what you might call the "fade zone".

Feather:
0 pixels

Feather:
6 pixels

Feather:
12 pixels

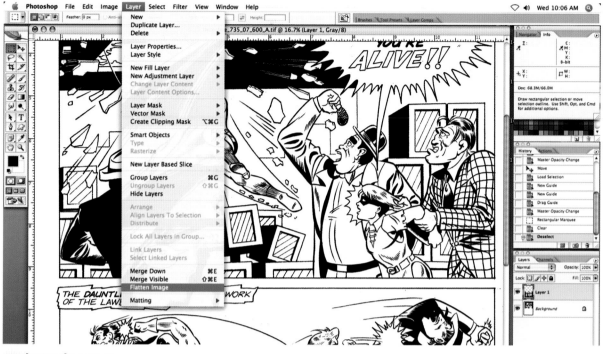

6 Flatten the Layers

Choose Layer > Flatten Image to permanently merge the two scans into one file.

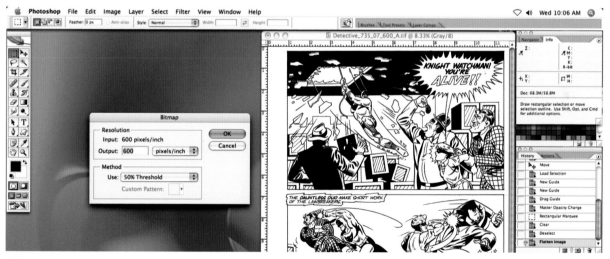

7 Convert Back to Bitmap

Convert the image back to black and white by choosing Image > Mode > Bitmap. Be sure to use the settings 50% Threshold and 600ppi.

Pro Tip Stitch In Grayscale Mode

In step 3, we instructed you to convert your Bitmap scans to grayscale for stitching. That's because the feathering trick we showed you requires use of Layers, which aren't available in Bitmap mode. When stitching is complete, we tell you to convert the image back to Bitmap mode so that the line art will be solid black again, as line art should be.

All About Trim Size, Safe Area and Bleed

Trim Size

Comic book pages are printed on oversized sheets of paper, generally eight pages to a sheet. The sheets are then folded, put in order, stapled, and trimmed down to final size, which is also called the *trim size*.

Safe Area

Folding and binding machines aren't perfectly precise, so the position of the printed artwork on the page varies slightly. To ensure that nothing important gets trimmed away, artists avoid putting critical art or type near the page edges. The *safe area* is the imaginary box within which you can assume the art is safe from being trimmed.

Bleed

In many of today's comic books, the printing extends all the way to one or more edges of the page. Because folding and binding aren't precise, it's not sufficient to print just to the trim edge. If the folding or trimming is off even a little, there will be slivers of unprinted white paper at some edges. To prevent that, the art is created larger than the trim size.

The extra margin of art area beyond the trim size is called *bleed*. Usually, ¼ inch (6mm) of bleed is standard for comic books.

What Bleed Isn't

It's important to know that making a page bleed doesn't mean creating the page at final size and then enlarging it a little. If you were to do that, important parts of the artwork would get cut off. Instead, artists create bleed by extending background shapes and colors beyond the final trim size.

LIFE SAVER

Remember to Color the Bleed

When you're coloring a page, you must color the bleed areas too! If you don't, you will end up with slivers of uncolored artwork along page edges.

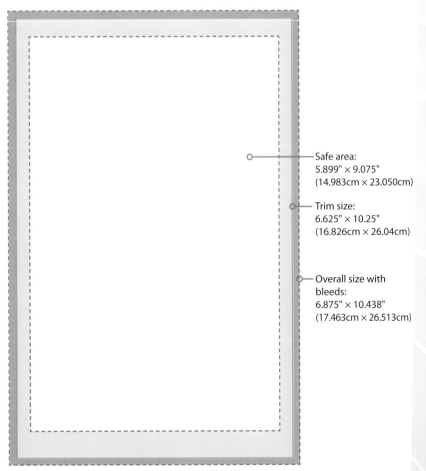

Safe area:
5.899" × 9.075"
(14.983cm × 23.050cm)

Trim size:
6.625" × 10.25"
(16.826cm × 26.04cm)

Overall size with bleeds:
6.875" × 10.438"
(17.463cm × 26.513cm)

Dimensions of a Traditional Comic Book Page in the U.S.

Cropping and Sizing the Page

After you've scanned and stitched a comic page, you must crop it to the correct dimensions, making sure the artwork is properly positioned on the page. Here's how to do it for a basic comic book page with no bleeds.

1 Crop to Position the Art on the Page

Open your scanned page and choose View menu > Fit On Screen. Refer to the crop marks on the original art and use your powers of observation to gauge how the scan differs from the original. Is the scan off-center? Using the Crop tool, crop the scan to approximate the way the original artwork is positioned within the crop marks.

2 Change the Image Width

Choose Image menu > Image Size. Check "Resample Image" (to ensure that the resolution stays at 600ppi) and "Constrain Proportions." Then change the width of the image to 6.875" (17.463cm).

Since this is a Bitmap image, the resampling methods have no effect; these options apply only to grayscale and color images.

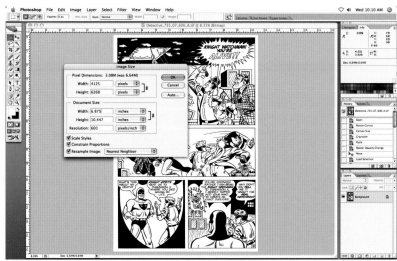

3 Set the Anchor Point

Choose Image > Canvas Size and set the canvas height to 10.438" (26.512cm). Set the anchor point to the center block so that the new vertical space will be distributed evenly above and below the existing image area.

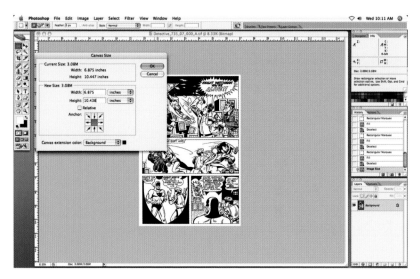

4 Save the Image

Save the document as a TIFF file. If disk space is a concern, you can save the image with LZW compression enabled. (See Vocabulary sidebar below.)

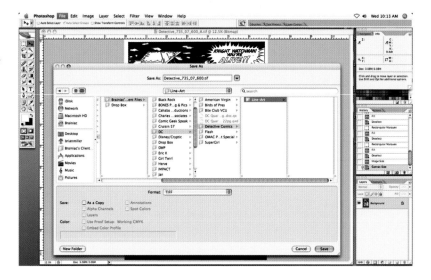

VOCABULARY:

LZW Compression

File compression is an attractive option when you need to conserve disk space, but not all compression methods are created equal. LZW is a type of *lossless* compression, meaning no information is sacrificed to achieve the smaller file size. LZW compression won't affect the quality of a TIFF image in any way. (By contrast, the JPG file format is a form of *lossy* compression. Each time a JPG is opened and resaved, some image quality is lost.)

If you're sending images to a client or prepress house, first make sure they accept LZW-compressed files.

When a page has bleeds (see page 26), you still need to crop it as explained in Lesson 1.3, but you also have to be careful not to crop away the bleed areas.

To follow along, open the file Aviatrix_04.tif from the "Bonus Art" folder on the CD-ROM.

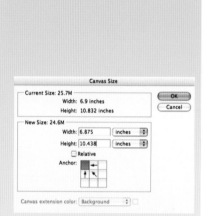

1 Examine the scan and look for bleeds. In this example, you can tell that there will be bleeds on the left, right and bottom edges because the artwork extends outward at those edges with no defined border.

The blue lines indicate where the scan should be cropped:

Bottom and right edges: The white area beyond the bleed is not needed for printing, so we're going to crop it out.

Left: The left edge of the artwork is right at the edge of the scan, so no cropping is needed on this side.

Top: The top edge doesn't bleed, but the white space is wider than it needs to be, so we will crop it out.

2 Use the Crop tool to remove the unneeded areas from the top, right and bottom edges of the scan. Crop just to the edge of the inked art; do not crop any of it away.

3 Now choose Image > Canvas Size and set the canvas size to 6.875" × 10.438" (17.462cm × 26.512cm), the dimensions of a traditional comic book page including bleed. Set the Anchor to the top left corner to ensure the canvas is not changed on the two sides of the image you just cropped.

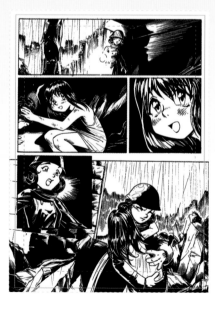

4 Here is the cropped art, correctly sized and correctly positioned on the page. The safe area is everything inside the blue-dashed box; the bleed is everything outside the green box.

Finalizing a Page With the "Hi-Fi Step 1" Script

So you've scanned your artwork, or maybe someone else scanned artwork and sent some files to you for coloring. The art is "in the computer," and you're ready to go!

Almost. First, you need to convert to RGB, change the ppi, prep the canvas for color and secure the line art in its own channel. It's about twenty steps in all, and they would be time-consuming if you had to do them manually. Fortunately, we've given you a Photoshop script called "Hi-Fi Step 1" to automate the process. You're going to love it.

LIFE SAVER

Get Ready to Use the Hi-Fi Scripts

On the CD-ROM in "Photoshop Presets" subfolder named "Hi-Fi Scripts," you'll find:
- Hi-Fi Step 1
- Hi-Fi Step 2
- Hi-Fi Step 3

You will need them all eventually, so be sure they are installed per the directions on page 11.

1 Open the Line Art
Open a black and white line-art file in Photoshop. Make sure you've installed the scripts as directed on page 11. Launch the Hi-Fi Step 1 script by choosing File menu > Scripts > Hi-Fi Step 1.

Pro Tip Protect Line Art in a Channel

Before Photoshop gained Layers in version 3, it had channels. Back then, everyone who used Photoshop for coloring line art wished there was a way to float the line art over a background that you could paint on, the way the character cel in an animated cartoon floats over the painted background plate. In the absence of Layers, artists figured out they could use a channel.

You can think of a channel as a container able to hold any image containing up to 256 shades of gray. The channel lets you view the line art, yet protects it from accidental modification because you can't change it while working on your RGB color file. Using a channel for the line art also leaves the Background layer completely blank so that you can paint into areas that would normally be occupied by line art, without affecting the line art.

This makes coloring easier and faster, and it will help later on with trapping and color separation.

Other benefits to using a channel for the line art:
- The file size will be much smaller.
- In its channel, the color of the line art will always remain 100% black (100K).

If your image-editing software does not provide channels, don't fret. You can place your line art on a layer. Just be careful not to alter the line art or accidentally merge it into the color art. If your software supports CMYK color, it should be possible to make a final color separation similar to the ones done in Photoshop that we will show you later in this book.

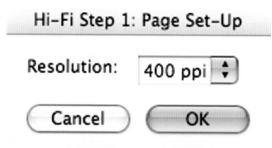

Hi-Fi Step 1: Page Set-Up

Resolution: 400 ppi

Cancel OK

2 Choose Specifications When the Action Prompts You
The script will give you options for paper type and
resolution. Use the defaults, matte paper and 400ppi,
unless you have specific knowledge that your project
requires different settings.

Preview:
More Uses for Channels
Channels can also be used to save pat-
terns, save selections, and make new selections.
We'll explore channels further in chapter two.

4 Check the Layers Palette
Go to the Layers palette, and you'll see that your back-
ground layer is now empty.

That's it. Really. We thought you'd love it!

This file is now ready for the next stage and the next
chapter, flatting.

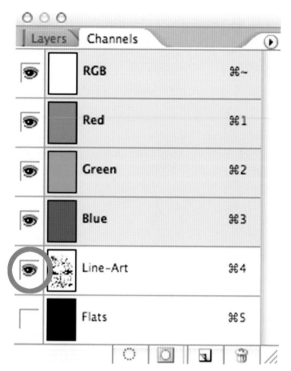

3 Unhide the Line Art
While the plug-in is running, your black-and-white art-
work will seem to disappear, leaving a blank white canvas.
Don't panic. It's safely hidden in a channel—named Line-Art,
naturally.

Go to the Channels palette, click the eyeball next to the
Line-Art channel to unhide it, and you will see your line art
again. (Be sure to click just the eyeball; if you click the entire
channel, it will be editable and you might erase or change
the line art.)

Install the Hi-Fi Color Settings
On the CD-ROM, we've provided you with a CMYK setup file
named "Hi-Fi Color Settings." These settings will help you
achieve visually attractive color separations that will repro-
duce equally well on newsprint, matte paper and glossy cover
stock. Select "Hi-Fi Color Settings" in your Photoshop color
preferences (see page 11 for directions). These will remain your
settings unless you change them. People not coloring for print
need to install the Hi-Fi color settings. (Whether you are using
Photoshop for print or Web, you will achieve excellent results
using Hi-Fi's settings, though it is not necessary to install them
for Web-only coloring.)

If you're coloring artwork for print, enable "CMYK Preview"
during coloring and Photoshop will display a more accurate
representation of how your colors will reproduce when profes-
sionally printed.

Check the Specs!

After you run the page prep action on a page (previous lesson; pages 30–31), the very next thing you should do as a comic book colorist is verify that the page you are about to color is at the correct resolution and size. You should do this for every page you color. Even if you got the scanned line art from someone else. Even if you're on a tight deadline.

Why? There are several good reasons.

1. Often, due to time constraints, a penciller or inker will not have time to turn his original artwork in to the publisher. Instead, that person may scan the artwork himself and send it directly to you. As the colorist, you are responsible for ensuring the page dimensions are correct. You may be the last link in the chain of people dealing with the line art. If you turn in color files that are the wrong size, you will take the heat. The publisher won't care who is to blame for the original scanning.

2. While you're coloring, the person at the publisher who adds word balloons and lettering is using the black-and-white scan to get the lettering done. If you both aren't working from the same properly sized black-and-white file, then the lettering won't align properly, if at all, with your finished color file. If your file is the wrong size, guess who gets to redo all his fabulous color work?

3. Just do it. It takes only a few seconds.

Remember, you and the person doing the lettering must be working from the same line-art file. So before you change the dimensions of a scan, make sure someone else hasn't already started using it to lay out a book. If someone has, make sure you both agree to use the new file.

> "[W]ith great power there must also come--great responsibility!"
>
> —Marvel Comics' *Amazing Fantasy* #15, August 1962

> "The buck stops here!"
>
> —Sign on the desk of Harry S Truman, 33rd president of the United States

> "I always check the specs on every page I color. Except for that time I didn't, and they were wrong. Oops."
>
> —Brian Miller, colorist

VOCABULARY:

Bitmap

When is a bitmap not a bitmap? When it's a BMP.

At the dawn of the desktop publishing revolution, Apple, Aldus, Adobe and other companies used "bitmap" to refer to a digital image made of solid areas of black and white, with no color or shades of gray. (This is also known as line art.)

When Microsoft created Windows, they called their default image file type BMP, also referred to as a "bitmap." A Windows BMP file can be black-and-white or color.

Sometimes an editor will ask for a "bitmap" of a piece of artwork, and a Windows user might think the editor is asking for a BMP file. What the editor really wants is an image scanned in Bitmap mode. Windows BMP files are primarily for use by the Windows operating system; they aren't suitable for either Web graphics or four-color printing.

In this book, "bitmap" always refers to a scan done in Bitmap mode. As a general rule, any line art you scan in Bitmap mode should be saved in TIFF format.

Scanning Specs at a Glance

	Inked art (line art)	Pencilled art	Color art
Scan settings	Bitmap mode, 600dpi, 100% size	Grayscale mode, 400dpi, 100% size	RGB mode, 400dpi, 100% size
File specs for Web	RGB mode, 72ppi at desired final size		
File specs for printed comic books	CMYK mode, 400ppi at desired final size		

Page Specs for Traditional Comic Books at a Glance

These are the page specs used by Marvel Comics, DC Comics and the majority of U.S. comic book publishers. Follow these specs unless directed otherwise by your editor.

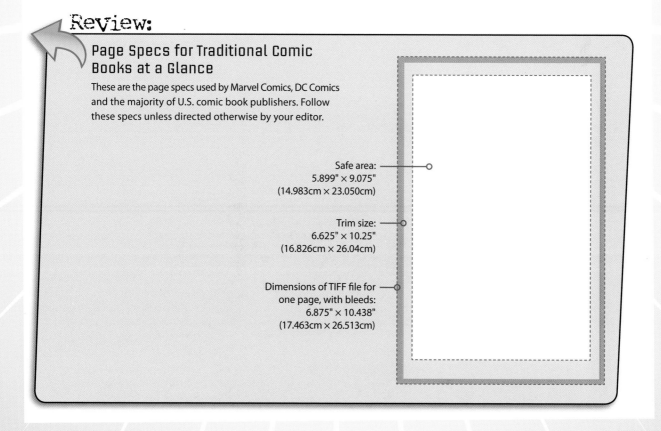

Safe area:
5.899" × 9.075"
(14.983cm × 23.050cm)

Trim size:
6.625" × 10.25"
(16.826cm × 26.04cm)

Dimensions of TIFF file for
one page, with bleeds:
6.875" × 10.438"
(17.463cm × 26.513cm)

RGB vs. CMYK:
The Politics of Color Spaces

Aspiring colorists often ask me whether I color in RGB or CMYK mode. When I answer RGB, I sometimes see a look wash over the person's face as if I just shot their dog, revealed the Roswell conspiracy to be a hoax, or explained that the androgynously named Terry Moore is, in fact, male.

Often, this aspiring artist has struggled to learn computer coloring from websites or from well-meaning books that contain one chapter on coloring line art. He may have read about a respected colorist who works in CMYK mode.

I know colorists whose work I admire who color in CMYK mode. They have refined their techniques and their style; CMYK works for them. I would never try to change the way a master artist uses her tools.

My personal philosophy can be summed up with four words: *Color for the medium.* What does that mean

exactly? Oil paint is made for canvas; tattoo inks are made for flesh. RGB mode is meant for computer monitors, which create colors with red, green and blue light. RGB is capable of producing bright, saturated colors that CMYK inks on paper can't match. There are also CMYK colors that monitors can't display.

When Adobe designed Photoshop, they assumed users would edit in RGB, then convert to CMYK for print if needed. That's why many Photoshop features are either disabled or work poorly in CMYK mode.

So, you might wonder, how does anything ever get colored accurately? At Hi-Fi, we color in RGB mode with the "CMYK Preview" feature enabled, and then we convert to CMYK to create the final files for print. The results are repeatable and consistent across multiple computer platforms, monitor types and colorists.

Working in RGB also gives you more flexibility. Say you have a color image that the publisher wants to use as a color ad in a newspaper, as a direct-mailed glossy postcard, in a television commercial, and also on a website. From one master RGB file, Photoshop can do custom color conversions for a broad range of mediums including a CMYK version that will reproduce accurately on newsprint, another for the glossy postcard, an RGB version with colors adjusted for video, and so on. Since the CMYK gamut is mostly inside of the RGB gamut, work done in CMYK can never be "expanded" to make full use of the RGB color space.

Having trained many colorists over the years, I can vouch that working in RGB mode is the most intuitive, natural and fastest way to learn how to color and color well.

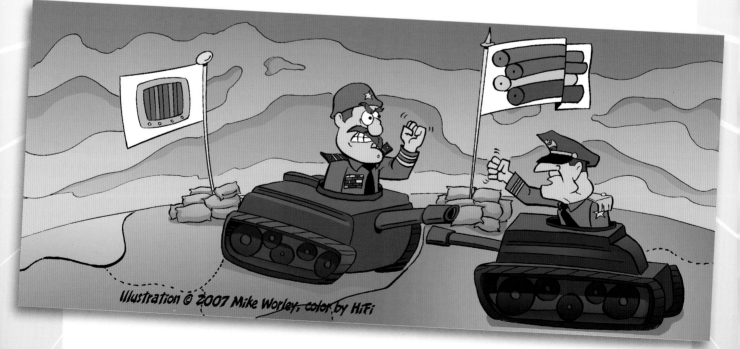

COLOR STRATEGIES
Art by Mike Worley
Color by Hi-Fi

For homework answers, visit www.hifidesign.com.

Assignment 1:

Resolution and Dimensions

It's time to test your knowledge of what scanning resolutions work best for different needs. If you have a scanner, you can do this assignment using your own photos and line art. If you don't have access to a scanner, look at the files in the chapter one "Homework" folder on the CD-ROM and shown on this page.

1 Scan in a color photograph at 72dpi and 100% size (use your scanner's default settings for a photograph). Save the file as a JPG.

What would be a good use for a 72dpi JPG?

2 Scan the same photograph at 400dpi and 100% size. Save the file as a TIFF.

What would be a good use for a 400dpi TIFF?

Extra Credit

a Open the JPG from step 1 of this homework assignment in Photoshop. Choose Image menu > Image Size, check "Resample," and increase the size by 3 inches (8cm) in each direction. How does the resampled image look?

b Reopen the JPG from step 1. Choose Image > Image Size and again check "Resample," but this time, increase the resolution to 400dpi. How does it look? Choose View > Actual Pixels to be sure you are seeing the image at 100%.

c Open the TIFF from step 2 in Photoshop. Increase the size of the image by 3 inches (8cm) (with "Resample" checked). Did it become fuzzy? Now, decrease the image size to 72dpi (again with "Resample" checked). How does it look?

The above experiments demonstrate an important fact: You can decrease the size or resolution of an image, but you cannot increase it without loss of quality. When you try to add pixels to an image, it becomes fuzzy because the software can only approximate as it tries to fill in the missing data.

JanesWorld_300_high.tif
This image began life as a 600dpi piece of line art. Then it was colored and down-sampled to 400dpi for printing. There's plenty of detail, and the linework is crisp.

JanesWorld_300_low.tif
This image began at 72dpi and was resampled *up* to 400dpi for printing. The loss of quality is evident.

For homework answers, visit www.hifidesign.com.

Assignment 2:

Stitching and Aligning

In this chapter, you learned how to stitch scans together. You'll recall that most scanners can't accommodate an entire 11" × 17" (28cm × 44cm) page of line art, so you end up scanning the art in at least two pieces.

For this assignment, you will need the six files in the "Stitching" folder on the CD-ROM. Each file contains half of a page of artwork. Your assignment is to turn those six half-pages into three solid pages. As a reminder, the basic stitching and aligning process is:

1 Open the files for the top and bottom halves of the page.

2 Add canvas (white space) to the top-half file to make room for the bottom-half.

3 Convert both files to grayscale.

4 Copy the bottom-half artwork and paste it into the top-half file. (Remember to set the opacity of the pasted layer to 50% so you can see both pieces.)

5 Move the bottom-half until it aligns as closely as possible with the top-half.

6 Use the Marquee tool with Feathering to get rid of the overlap and disguise the seam.

7 Flatten the image, convert it to Bitmap mode, and save it as a new file.

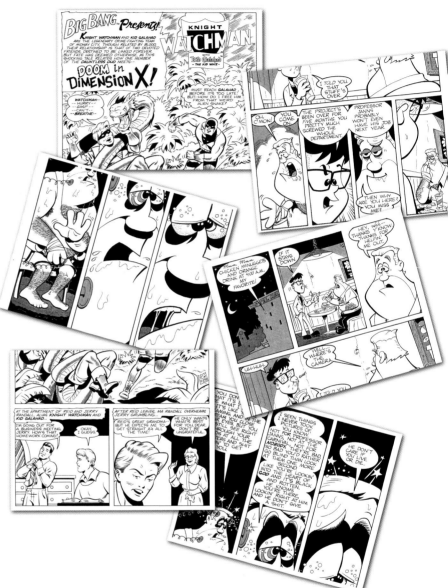

Review:
Stitching and Aligning
For the detailed account of how to stitch and align, go back to pages 22–26.

Preview:
Use This Homework Art For Later Lessons
When you complete this homework, you will have three full comic pages that you can use to practice upcoming coloring techniques.

Assignment 3:

Adding Canvas

There are many reasons one might add canvas to an existing piece of art. For this assignment, you'll turn a piece of artwork into a poster by adding text across the bottom.

1 Open the file Enigmas_400.tif from the "Assignment 3" folder on the CD-ROM.

2 Practicing what you learned in this chapter, add 2 inches (5cm) of canvas to the bottom of the image.

3 Use the Type tool to add a title, date or whatever you want, without covering or changing the art.

Extra Credit

a Reopen the file Enigmas_400.tif from the CD-ROM.

b Add two inches of canvas again, except this time, in the Anchor box, click the bottom center square. Change the height to 12.32" (31.34cm). Where did the new canvas appear?

c What happens if you leave the Anchor point at its default position, the center square?

d What happens if you check the Relative box?

e Can you think of a time when you might need to change the canvas size for a piece of line art?

From *Digital Webbing Presents* #35: *The Enigmas*
Art and color by Brian Miller

Review:

Adding Canvas
The key to adding canvas is setting the Anchor point correctly. To review, see pages 22–28.

Illustration © 2007 Mike Worley, color by HiFi

flatting

In the previous chapters, you learned about scanning your comic book pages and preparing them for coloring. In this chapter, you will learn step by step how to create flat color fills, known in the industry simply as "flats." Flats are the foundation for your coloring. They resemble the style of coloring that was popular in comic books before the advent of digital color. If you have ever read a comic book from the 1970s, you've seen flat color. Keep that in mind as you go through the steps in this chapter.

As with most art-related tutorials, there are usually multiple ways to achieve each goal. In this chapter you will learn the basic method for flatting as well as a few choice Life Saver tips. Once you have flatted a few pieces of artwork and experimented with the Pro Tips, you will be able to adapt all these instructions into a system that best suits your personal style of working. Consider this chapter the foundation upon which you'll continue to build your work, year after year.

This is also the part of the book where you will see that there is no magic "color" button in your image-editing software. The software will not color the artwork for you, but it will allow you the flexibility to color in ways not possible before the emergence of digital coloring. You can do it.

SCARLET MUSKETEER & DYNO DOT-GAIN
Art by Mike Worley
Color by Hi-Fi

Flatting From the Background Up

We're going to teach you a method in which you flat the entire piece with the background color, then work from back to front, flatting smaller and smaller areas as you go. This method is faster because you don't have to select and color as many individual areas.

LIFE SAVER

Heading Out to Get Some Color? Bring Your SPF

You wouldn't go to the beach without your suntan lotion, would you? Of course not. Don't dive into flatting without Hi-Fi's SPF method for flatting.
1. **S**elect an area
2. **P**ick a color
3. **F**ill the selection
Now you're ready to hit the surf and become a flat master.

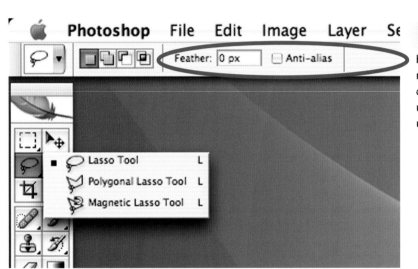

1 Configure the Lasso
Select the Lasso tool from the Toolbar. Tool options will appear under the menu bar. (If the options aren't there, choose Window menu > Options to unhide them.) Make sure Anti-alias is unchecked, and set Feather to 0 pixels.

2 Configure the Marquee
Now choose the Marquee tool from the Toolbar. Make sure Anti-alias is unchecked and that Feather is set to 0. For the Style option, choose Normal.

Due to the hand-drawn nature of comic artwork, it is rare that you'll use the Marquee tool when flatting or rendering. Still, it gets used occasionally, so you will want to be sure its settings are correct. Otherwise you could end up with an anti-alias area in your flats that you cannot easily select with the Magic Wand tool later.

3 Configure the Magic Wand
Select the Magic Wand from the Toolbar. Make sure Anti-alias, Contiguous and Sample All Layers are all unchecked. Set the Tolerance to 0.

LIFE SAVER

The Magic Wand With the "Contiguous" Option Disabled

The Magic Wand is especially powerful when you uncheck the Contiguous option. Try the following experiment.

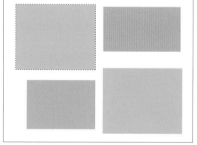

1 Create a new Photoshop document. Select a squarish area with the Marquee tool, choose a color from the Color Picker, then choose Edit menu > Fill, and fill the selection with the foreground color.

In the same manner, create a few areas of different colors, then one more area exactly the same color as the first one. (Click the Eyedropper tool on the first filled square to get that color back as your foreground color.)

2 Select the Magic Wand tool, check the Contiguous option, and click the first square. Only the first square will be selected.

3 Now uncheck the Contiguous option and again click the Magic Wand on the first square. This time, both the first and last squares will be selected.

As the experiment shows, the Contiguous Magic Wand selects adjacent same-colored pixels (*contiguous* means "touching"), while the non-Contiguous Magic Wand selects *all* same-colored pixels throughout the image.

The non-Contiguous wand will be very useful in the next chapter on rendering. Imagine a typical comic book page with a hero who appears in several panels wearing a blue and red costume. To select all the red costume elements for rendering, simply click any one of them with the non-Contiguous Magic Wand, and you'll instantly select them all. If you had to select each red area individually, it would take longer and you might make the embarrassing mistake of forgetting to render a leg, glove or arm.

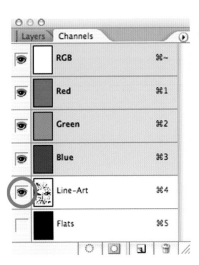

4 Open the File and Unhide the Line-Art Channel

Open the file you're going to use for the remaining lessons in this chapter. You can follow along with us using the file Kid_Galahad_08_400.psd from the chapter two "Lessons" folder on the CD-ROM; it has already been completely prepared for flatting. Or you can use the page you stitched and cropped during the lessons in chapter one. If you use your page, just be sure to run the Photoshop script "Hi-Fi Step 1" on it now, if you haven't already. (The instructions for doing so are on pages 30–31.)

Now that your stitched, cropped and prepped file is open, choose Window menu > Channels to open the Channels palette. The line art resides in a separate channel called "Line-Art," where it is protected from being changed accidentally. Click the eyeball next to the Line-Art channel to unhide it so that you can see the line art as you flat.

5 Fill the Entire Page

Choose a color from the Swatches palette (Window menu > Swatches). This will become the color for the areas between the panels. It can be any color as long as it's light enough that you can still see the line art.

Now, fill the entire background layer with the chosen color by selecting Edit menu > Fill. Or, you can do it faster by using the keyboard shortcut Option-Delete (PC: Alt-Delete). It may seem odd to put this color all over the page, but remember, we're flatting from background to foreground, from general to specific—because when you don't have to make as many complex selections, the process goes faster.

KEYBOARD SHORT CUT

Option-Lasso (PC: Alt-Lasso)

You may be familiar with the Lasso tool, which lets you create free-form selections. You may not have tried the Polygon Lasso tool. It lets you click or tap at points, which are then connected with straight lines to make the selection.

When you're making a new selection with either the Lasso or the Polygon Lasso, you can switch temporarily to the other Lasso tool by holding down the Option key (PC: Alt key). This works on the fly, even in the middle of a complex selection. This technique is very handy for selecting areas with both straight and curved edges. Try it!

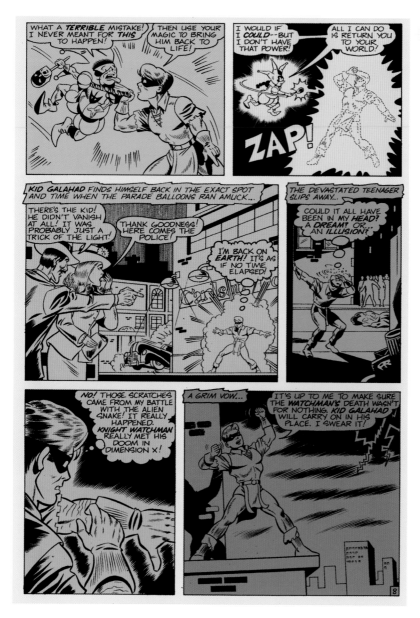

6 Fill Each Panel

Use the Lasso tool to make a selection around one panel. Guide the Lasso right down the center of the panel border's linework so the edge where one color meets another will be hidden beneath the line art. Once the selection is made, fill the area with a color (Edit menu > Fill or Option-Delete [PC: Alt-Delete]).

Repeat this step for the remaining panels on the page, making each panel a color that is visually distinct from the others. Your goal is to break each panel out into its own color.

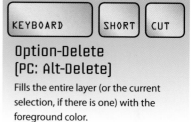

KEYBOARD SHORT CUT

Option-Delete [PC: Alt-Delete]

Fills the entire layer (or the current selection, if there is one) with the foreground color.

Don't Spend Too Long Hunting For the "Right" Color

You might be tempted to spend hours choosing just the right flat colors. Certainly you want to choose tasteful colors and take time of day, setting and mood into account, but remember that your primary goal is to get the page broken down quickly. When you're done flatting, you can always go back and re-flat areas by selecting them with the Magic Wand tool. Usually that approach is faster than fretting over each and every color choice.

For now, choose your flat colors from the Swatches palette and focus on learning the tools and techniques. Later, we'll talk more about selecting colors and using custom color palettes.

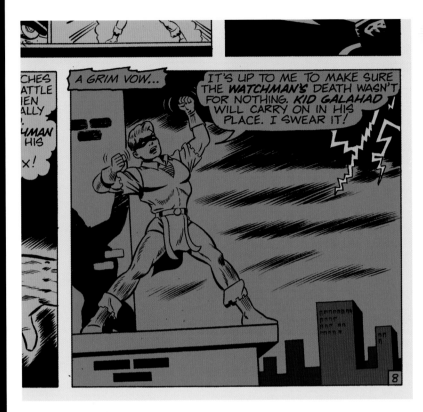

7 Start Flatting Within a Panel

Take a minute now to study the time-saving Life Savers and Keyboard Shortcuts on this page and page 45.

Back? OK. Use the Lasso tool to select the most distant buildings in the bottom right panel. Pick a color from the Swatches palette, then press Option-Delete (PC: Alt-Delete) to fill the selected areas with color.

Now move forward in space and, using the tips on these pages, flat the building in the middle-ground. Also go ahead and flat the lightning.

Flip to page 46 to continue this flatting lesson.

LIFE SAVER

The Fast Way to Select Areas Adjoining Solid Black

Here are two ways to select the boy's face for flatting. Try both using the file Picture Taker.psd from the chapter two "Lessons" folder on the CD-ROM, and see which is faster.

Selection Method 1
Carefully lasso through the black line where the boy's neck meets his collar, then continue carefully lassoing all the way around the outline of the head. We've used a red outline to indicate approximately where to lasso.

Elapsed time: 5 minutes

Selection Method 2
Carefully lasso through the black line where the boy's neck meets his collar, then sweep broadly around the rest of the head, directly through the solid black area.

Elapsed time: 5 seconds

Finished Fill
Fill the selection with a color. The result is the same with either selection method. The fill color won't show through the black, so there's no need to spend extra time tightly lassoing the contours of an area that's surrounded by solid black.

LIFE SAVER

finish Selections faster With the Negative Magic Wand

The Magic Wand selects a zone of a certain color with one click. With the negative Magic Wand, you can subtract areas from the selection just as quickly.

Lasso the Hands

Open the file Picture Taker.psd from the CD-ROM. Select the Lasso tool and set its tolerance to 0, then lasso the boy's hands. His jacket and shirt are the same color as his hands, so lasso carefully through the linework where those areas meet. You do not have to be so careful where the hands meet areas of different color; you can lasso roughly right through the steering wheel and seat.

Part from the selection

Select the Magic Wand tool; the cursor becomes a wand. Now press and hold the Option key (PC: Alt key). A minus sign (-) appears next to the cursor. Keeping the Option (or Alt) key pressed, click the gray-colored part of the steering wheel to subtract it from the selection.

Subtract the Unwanted Area

Do the same to the darker gray-colored part of the seat, leaving only the hands selected.

Pretty cool, eh? And much faster than if you had to use the Lasso all the way around each hand. Now these hands are ready to be filled with the desired flesh color.

On your own, try using a similar process to select the face and neck.

KEYBOARD SHORT CUTS

Positive and Negative Selecting

After you try the mini-lesson above, check out these Keyboard Shortcuts and practice using them. With one modifier key, you can change the Lasso or the Magic Wand to either an additive or subtractive mode. There are many uses for this. For one thing, you'll never again have to start over on a painstaking selection that wasn't right the first time.

Shift-Magic Wand

Adds the new Magic Wand selection to the current selection.

Option-Magic Wand [PC: Alt-Magic Wand]

Subtracts a Magic Wand selection from the current selection.

Shift-Lasso

Adds the new Lasso selection to the current selection.

Option-Lasso [PC: Alt-Lasso]

Subtracts a Lasso selection from the current selection.

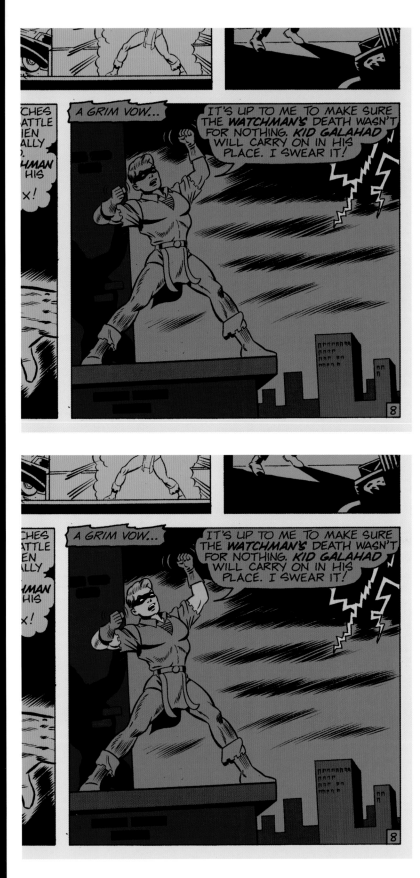

8 Flat the Foreground Building

Select the building in the foreground using the Lasso tool. Pick a brick-like color from the Swatches palette, then fill it by pressing Option-Delete (PC: Alt-Delete).

Next, select the ledge Kid Galahad is standing on. You might pick a grayish concrete color from the Swatches palette for the ledge as a way to provide contrast against the bricks in the building. Fill your selection with your chosen color.

9 Start Flatting the Figure

Time to focus your attention on the figure. Select Kid Galahad's hair using the Lasso tool. Pick a red-orange color from the Swatches palette, then fill (Option-Delete or Alt-Delete).

Next use the Lasso to select the areas of his flesh. Pick a light peach color from the Swatches palette, then fill (Option-Delete).

LIFE SAVER

Use Distinct Flat Colors to Make Learning Easier

When you've completed this lesson, you'll be able to use your flatted art in the next chapter to practice rendering.

When you start rendering, you'll be introducing two subtle variations of each flat color. It will be easier to keep the colors straight if you use a different, distinct flat color for each element in a panel.

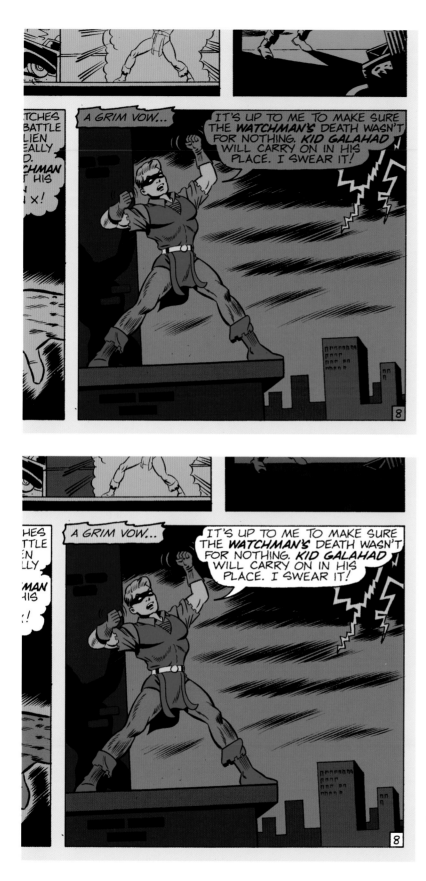

10 Flat the Costume

Still working on Kid Galahad, use the Hi-Fi SPF process and the Life Savers from pages 44–45 to flat the red, green and yellow areas of his costume. (Hint: It may be faster to flat all the red areas, then the green ones, then the yellow ones.)

11 Flat the Text Areas

To finish out this panel, use the Hi-Fi SPF process to flat the caption box, word balloon and page number box. Once you have completed the panel, use the SPF process to flat the remaining panels on the page.

Hi-Five

Way to go—you've flatted one panel! Take a minute to reflect on what you have accomplished. How does it feel to use the Lasso and Magic Wand tools to make your selections? You will feel more comfortable after you have finished this page. Let's keep going.

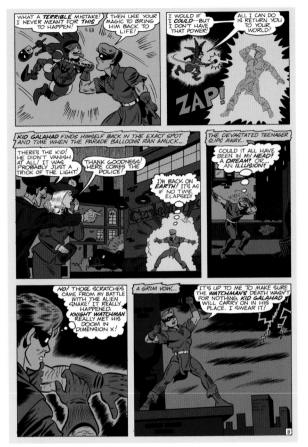

12 Copy Your Flats

Your page is completely flatted, but there's a bit more to do before you can close the page.

When you ran the Photoshop script "Hi-Fi Step 1," a new Channel was created named "Flats." We're going to copy the flats you just finished and paste them into the Flats channel.

To start, choose Select menu > All (or Command-A [PC: Ctrl-A]), then Edit menu > Copy (or Command-C [PC: Ctrl-C]).

13 Go to the Flats Channel

Go to the Channels palette and click the channel named Flats. That will deselect the RGB channels, and you'll see only a black canvas. (There is nothing in the Flats channel yet.)

Sometimes comic book artwork has the word balloons and lettering right in the artwork, like this example. Other times, the word balloons and lettering are added later, after the artwork is colored. You will see both types of artwork in this book, although the majority of comic publishers are moving away from having the word balloons and lettering within the artwork. A good reason for this change is global distribution. If the artwork contains no word balloons or lettering, it becomes much easier for the publisher to create a unique version of the book for different countries with word balloons and lettering tailored to each specific region and language.

14 Paste the Flats Into the Flats Channel

Choose Edit menu > Paste, or press Command-V (PC: Ctrl-V). You should now see a grayscale version of your flats.

Preview: →

Using the Flats Channel

Having your flats in a separate channel will be helpful in subsequent chapters as a way to save time and avoid mistakes. One benefit of the flats channel is to avoid making repetitive selections during rendering. Imagine creating a fully rendered character with blonde hair then your editor telling you the character was supposed to be a redhead. Oops! You can go to the flats channel and use the Magic Wand tool to select the flat area for the figure's hair, then go back to the composite RGB channel and change the hair color. What would have been a difficult correction is now a quick fix.

This is one of the many ways the flats channel can save you time. As you proceed through the other chapters in this book you will discover more.

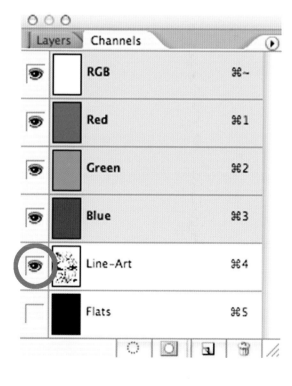

15 Unhide the Line Art

Go to the Channels palette and click the channel named RGB. That will deselect the Flats channel. Click the eyeball for the Line-Art channel to unhide it.

Hi-Five You have successfully flatted your first comic book page! If this is your first time using the Lasso and Magic Wand tools for flatting, you might have found this lesson slow-going. Don't be discouraged. With practice, you will soon be able to flat a typical comic book page in about an hour.

Remember, flat the page, flat each panel, and then do the insides of the panels one by one.

For homework answers, visit www.hifidesign.com.

Assignment 1:

Flatting a Cover

For this assignment, you get the fun of flatting a piece of cover art from Terry Moore's *Strangers in Paradise*. This cover features blonde-haired Katchoo, one of the two female lead characters in the series.

Preparation

1 Open the file named Katchoo_pencils.tif from the chapter two "Homework" folder on the CD-ROM.

2 Run the Photoshop script "Hi-Fi Step 1" (installation instructions are on page 11; instructions for running the script are on pages 30–31). When the script is finished running, remember to unhide the newly created channel called "Line-Art" by going to the Channels palette and clicking the eyeball next to that channel.

Flatting

You're ready to start flatting. This assignment will introduce you to a new technique: using the Zoom tool to magnify. When you master the Lasso and Zoom tools, you will be ready for the second homework assignment in this chapter.

1 Choose Edit menu > Select All, then Edit menu > Fill to fill the canvas with a light color (we used C00/M05/Y25/K00). Remember, always fill the page with color first, followed by the individual panels. In this case the entire page is one panel.

2 Select the Zoom tool from the toolbar and zoom in on the image. You will notice that this piece is not inked; the artist chose to complete it entirely with pencils. When art isn't inked, you still add flats the usual way, but you will have to be even more careful with your Lasso so that the boundaries between different-colored areas don't show though the pencil work.

3 As an experiment to illustrate the previous point, zoom to 33% and flat Katchoo's necklace. Zoom to 50% and flat the star pendant. Now zoom to 100%. How well did you do? That's why you must zoom to at least 100% when flatting. For pencilled art, it can help to zoom in even closer than 100% to make sure you stay in the lines. With time, you'll get better and better with the Lasso, and you'll need to zoom past 100% only for small items.

4 Use the History palette to undo the changes from step 3.

5 Use the Lasso tool to "trace" Katchoo's hair. Make sure Anti-alias is off and that Feather is set to 0.

6 When the hair is selected to your satisfaction, choose a color in the Color Picker and select Edit menu > Fill.

7 Next, flat Katchoo's skin. Don't forget the bit at the waist.

8 Flat the shirt, then the pants. Go back and do the jewelry. Don't forget to use different and distinct colors for everything; this will help with your rendering in the next chapter.

9 All finished? Open our flatted version, the file named Katchoo_flat.tif from the CD-ROM. (It's also shown on page 156.) How did you do? Most of your colors will be different, but we mentioned at the beginning of this assignment that Katchoo is blonde. Did you remember?

Pro Tip Use Photoshop's History Palette

The History palette remembers your most recent commands and changes. If you make a mistake or change your mind, scroll through the list of commands until you find the change you made prior to your error. Click that change, and Photoshop takes the document back to that point.

Review:

Positive and Negative Selecting

As you complete this homework, the Keyboard Shortcuts you learned on page 45 will come in handy.

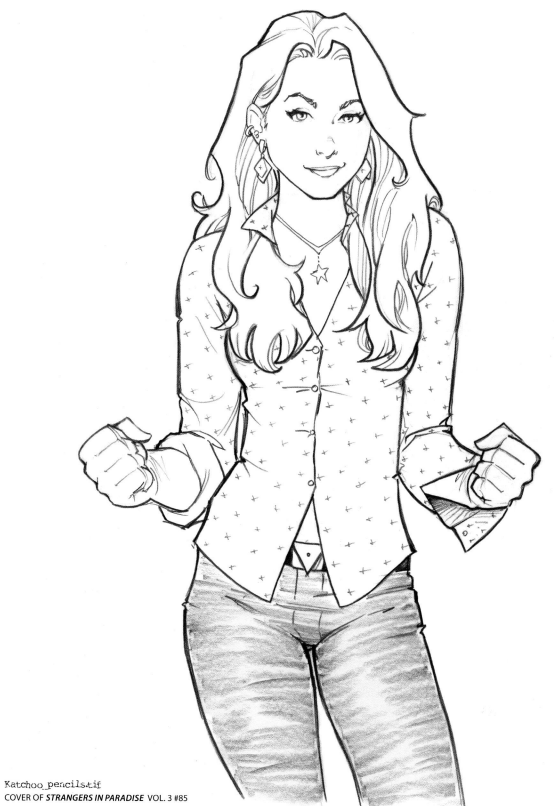

Katchoo_pencils.tif
COVER OF *STRANGERS IN PARADISE* VOL. 3 #85
Art by Terry Moore
Color by Hi-Fi

For homework answers, visit www.hifidesign.com.

Assignment 2:
Flatting an Entire Comic Book Page

This assignment will introduce you to two ways of flatting from background to foreground, and it will show you what to do with a page that has both bleeds and regular panels. You will also practice using reference to guide your color choices for a character.

1 Open the file labeled AQ_lineart.tif from the chapter two "Homework" folder on the CD-ROM.

2 Run the "Hi-Fi Step 1" script (installation instructions are on page 11; instructions for running the script are on pages 30–31). When the script is done running, remember to unhide the newly created channel called "Line-Art" by going to the Channels palette and clicking the eyeball next to that channel.

3 Also open the file AQ_reference.tif from the CD-ROM. Using previously colored pages for reference helps you keep the characters consistent throughout this assignment and future books.

4 Fill the entire top panel of AQ_lineart.tif with a light color—maybe a green for the hilly grass. The top panel bleeds at its left, top and right edges. You are responsible for coloring the bleed areas. (The background stays white below the bottom edge of the top panel.)

5 Next, flat the sky, then the farthest mountains. Continue flatting the remaining background elements, working toward the foreground. As you do this, try the following variations on the back-to-front flatting method. Both techniques take about the same amount of time; it just depends on what makes more sense to you.

Variation 1: Slash through anything that's in your way. For example, when you get to the hill, don't lasso around the monsters and people who are standing on the hill. Lasso right through them. Later on, you can pick the figures out all at once. When you are ready for the people you can color them all one color (usually skin tone, but these guys wear a lot of armor, so maybe the armor color), then break down the other parts as you go. (See the file AQ_first.tif on the facing page and on the CD-ROM.)

Variation 2: Lasso each shape carefully, going around anything that's in front of it. Using our hill with monsters and people on it as an example, flat only the visible parts of the hill while leaving the monsters and people the background fill color. When you get around to flatting the

figures, use your Lasso tool to make a large circle around them against the hill, then use the negative (-) Magic Wand to subtract the hill from the selection. Now all you have to do is fill with a color. (See the file AQ_second.tif on the facing page and on the CD-ROM.)

6 Make sure your reference page is open (AQ_reference.tif), then flat the main characters in the first panel. Be sure to break the characters down and flat them the same as they are on the reference. How? The first time you use a color, switch to the reference file and use the Eyedropper tool to select the color from the reference. Switch back to the

From Sherwin Schwartzrock's *Armor Quest #4* (Black Rock Graphics)

page you're coloring and do the fill. Next time you need the same color, you can get it from your page using the Eyedropper tool. Finish flatting the first panel.

7 Fill the second panel with a background color, then go ahead and start flatting the characters. Did you notice this artist hand-drew the word balloons? You'll have to make the insides of the balloons white so the lettering will be legible. (Occasionally in comics, you'll see a word balloon that contains a color in order to convey something about what's being said, but the letterer would make that decision.) You flatted these characters already in the first panel, so keep colors consistent (your own work in panel one becomes your reference for the remainder of the page). Use the Eyedropper tool to choose the colors from your page.

8 Finish the rest of the panels on the page. Save your page for use in the next chapter.

Front-to-Back Flatting, Method 1

Front-to-Back Flatting, Method 2

Extra Credit
Open the file AQ_reference_2.tif from the chapter two "Homework" folder on the CD-ROM. How many flatting errors can you find in it?

Rendering

Introduction by Paige Braddock, creator, *Jane's World*

Sometimes rendering makes the difference between a lackluster page or cover and a killer one. My first year of publishing *Jane's World* was a big learning year. I think I was four or five issues into the series, doing all the artwork and color work myself, when I happened to be in a comic shop in New York and came across *Jane's World* on the shelf. It had never dawned on me that some shops might not separate indie books from the mainstream superhero comics. In this particular shop, everything was on the shelf together in alphabetical order. That meant, of course, that my quaint little *Jane's World,* with its unsophisticated color covers, was surrounded by *Justice League* . . . yeah, all boobs and spandex. My covers were getting totally overwhelmed on the shelf. That's when I called Brian Miller. He worked his color magic on my covers and took my comic books to the next level. Off-the-shelf sales increased almost overnight. Brian's rendering of my line art with lighting, color and contrast brought the characters to life. He made them real.

COVER IMAGE, *JANE'S WORLD* VOL. 6
Art by Paige Braddock
Color by Hi-Fi

Rules of Light and Shadow

Hi-Fi's approach to coloring comic art has always been to use strong light and shadow in order to clearly define objects against a surface plane. Our goal is to create believable environments for characters to inhabit. We think that when stories feel more real, readers will relate to the characters on a more personal level.

When the light and shadow are clearly defined, it's especially important that they be *right*, or the scene won't look real. Rendering objects requires a basic understanding of the science of light and shadow because your coloring *must* be consistent with the light direction the artist has drawn or implied.

As you look at each of example, ask yourself where the light is coming from and how you can tell.

Rule 1: Light Travels in a Straight Line
This is important to know because it helps you create realistic shadows. If there's no obvious light direction in the art you're coloring, you may need to pick one and go with it. On the other hand, often the penciller and inker will indicate some shadows already. In those instances, study their shadows to understand where the light is coming from, then keep your work consistent with that.

Rule 2: The Color of the Light Affects the Perceived Color of Objects
Light (either direct or reflected) bounces and reflects, affecting the apparent color of the surface it strikes.

DIGITAL WEBBING PRESENTS #34: *THE ENIGMAS*
Story by Dustin Yee
Art by Casey Maloney
Color by Hi-Fi

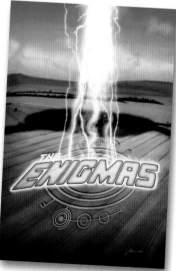

Rule 3: Cool Colors Recede; Warm Colors Advance
The apparent warmth or coolness of a color is called its temperature. Warm colors such as reds, oranges and yellows tend to come forward visually. Cool colors such as blues and greens appear to recede. You can use this in your coloring to heighten the sense of depth in the artwork. Remember, also, that color temperature is a relative thing: a golden yellow is warmer than a lemon yellow; an orangey red is warmer than a purplish red.

DIGITAL WEBBING PRESENTS #34: *THE ENIGMAS*
Story by Dustin Yee
Art and color by Brian Miller

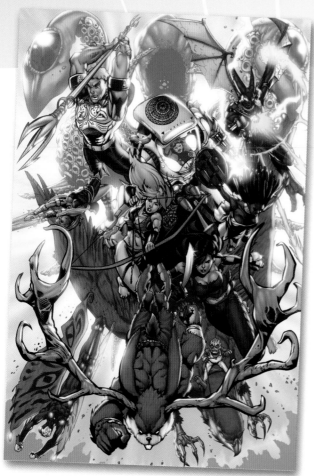

Rule 4: Distant Objects Appear Cooler and Softer-Edged
Particles in the atmosphere can make colors look muted and cooler in temperature, with less contrast. If you've ever seen distant hills on a hazy or smoggy day, you've probably noticed this phenomenon; it's called atmospheric perspective. You can exaggerate this effect when rendering to create depth or to focus attention on a subject.

DIGITAL WEBBING PRESENTS #34: THE ENIGMAS
Story by Dustin Yee
Art by Casey Maloney
Color by Hi-Fi

Rule 5: Shadows Behave in Predictable Ways
A shadow has five parts that are found on all objects, no matter what the shape. We'll get to shapes on the next page, but first, learn the basic shadow parts.

Highlight:
The area where light from the source strikes the object directly.
- The highlight directly faces the light source.
- The highlight is the lightest area on the object.

Core Shadow:
The area that receives no direct light.
- Located on the side of the object directly opposite the light source.
- The core shadow is the darkest and coolest area on the object.

Midtone:
Areas where light strikes the object indirectly, at an angle.
- Located between the highlight and the core shadow.
- The midtone is darker than the highlight, but lighter than the core shadow.

Reflected Light:
Areas where light is bouncing onto the object from nearby surfaces.
- Generally located near the edges of the midtone and the core shadow.
- The color of the area can be influenced by the color of the light and by the color of nearby objects that light is bouncing off.

Cast Shadow:
The area on a nearby surface where light from the source is blocked by the object.
- Located toward the side of the object directly opposite the light source; points directly away from the source.
- The core shadow's shape depends on the location of the light source. How dark the cast shadow is depends on factors such as the angle of the light and the presence of other light sources or nearby objects that might reflect light into the shadow area.
- The color of the cast shadow tends to be darker and cooler than that of the object's lit side.

find the Basic Shapes

Ever see an elaborate cake covered in frosting, sprinkles and designs made from sugar? Underneath all the frosting and decorations lie several plain-looking round cakes stacked many tiers high. The cake is the basic structure upon which the icing is built. Visualize your flatted line art as the cake, and the rendering as the fancy icing.

1 Take a look at the circle, square, triangle and rectangle. Simple outlines create two-dimensional shapes.

2 Flatting the shapes gives them color, but we can't tell much else about them yet.

3 Render the objects with simple, straight-edged cuts using different values of the same color, and you create the impression of shiny, flat objects.

4 Here are the very same flatted shapes rendered as three-dimensional objects. The circle becomes a sphere, the square becomes a cube or box, the triangle transforms into a cone and the rectangle becomes a cylinder.

From Basic Shapes, Realistic Rendering for Any Subject
If you can render a sphere, cube, cone and cylinder, you can render any subject in a comic book. Really—take a look at these examples.

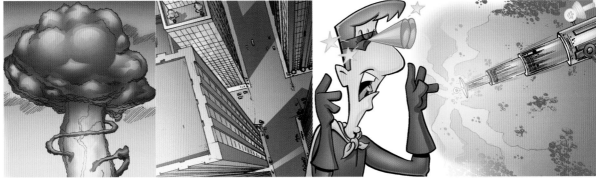

This explosion and cloud of smoke is nothing more than a series of interconnected spheres.

This cityscape is essentially several boxes stacked one upon the other.

The heat-vision this super human is using to defeat his foes is a simple cone.

This mega-heavy weapon is constructed out of several basic cylinders.

Cast Shadows

On this page, we have a box resting on a simple flat plane. Using light and shadow, the colorist can control how close the box appears to the viewer.

Use these examples to visualize how the light source in a scene might affect the objects and figures on a comic page. Remember, the light source can be somewhere outside the area of the drawn page. In this instance, look at the shadows the artist has drawn to understand where the light is coming from.

Light From Behind Subject
Here, the light source is behind (and slightly above) the box, so the box casts a long shadow toward the viewer. This shadow gives the viewer the sense that the box is closer to the viewer on the surface plane than the light source.

Light At Same Distance As Subject
In this example, the light source is above and parallel to the box on the surface plane. This causes the box to cast a shadow parallel to the box.

Light In Front of Subject
In this example, the light source is between the viewer and the box. The box casts a shadow back into the surface plane. This gives the impression that the box is farther from the viewer on the surface plane than the light source.

A Visual Guide to the Jargon of Rendering

Cut
The act of selecting an area with the Lasso tool. So named because, before computers, print production artists used to indicate color areas by cutting Rubylith (or other brands of transparent red film) to the required size and shape.

Cut and Grad (or Cut and Brush)
The act of making a cut with the Lasso tool and then using the Gradient ("grad") or Brush tool to paint the selected area.

Rim Lights
Thin cuts used to define the edge of an object or surface. Visually communicates the end of an area or where a space wraps around beyond the sight of the viewer.

Core Highlight Cut
This cut, which comes after the base and secondary cuts, creates the central highlight and draws the eye to important focal points in the composition.

Secondary Cut
The second cut you create. Adds an extra level of highlight to refine the rendering.

Base Cut
The first cut you create. Defines the general highlight area of an object or surface.

DETAIL OF COVER IMAGE, *THE TERRIFYING TALES OF TOMMI TREK* #2
Art by John Byrne
Color by Hi-Fi

VOCABULARY:

"Add cuts . . ."

The term *cut* not only means the act of making the selection, but also that of adding the color. If someone says, "Add cuts . . .," or "Use cuts to . . .," it is assumed that you will use the Lasso tool to make selections, then add color with the Brush or Gradient tools.

How to Add a Cut

 The **Brush** tool allows you to paint onto your image using a brush whose diameter is defined in pixels. The Brush tool is good for high-detail areas like faces, folds in clothing and reflective areas like chrome or glass.

 The **Gradient** tool blends the color from 100% to 0% within an image. Using the Gradient tool, click to choose a starting point for a color and then drag in the direction you'd like the color grade to descend (or ascend) to an ending point and release. Think of the Gradient tool as being directional. This can help you when establishing your light source.

 The **Lasso** and **Magic Wand** tools allow you to make selections. The selections you make will be defined by an edge made of dashed lines, sometimes referred to as *marching ants* because the little dashes appear to travel the path of your selection.

Swatches palette

A sky is a good candidate for a gradient, and can help you establish your light source. Imagine where your light source stems and drag the gradient to or from the area to realistically light an image.

THE TERRIFYING TALES OF TOMMI TREK #2
Art by Mike Worley
Color by Hi-Fi

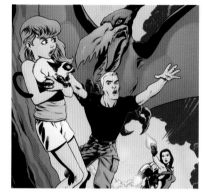

This final image was colored using the Lasso tool for selections and the Gradient tool to render the drawing. The Gradient tool is good for areas where you want general illumination and color such as skies, buildings, ships, planes and cars.

TOMMI TREK: CURSE OF THE SIAMESE SERPENT
Art by Steve Lightle
Color by Hi-Fi

Use the Brush and Gradient Tools Interchangeably

Each selection you make acts as a container. Only the selected areas are affected by the Brush tool or Gradient tool. Photoshop allows you to make multiple selections and have several active at the same time.

When making cuts it is important to visualize how you want to light a specific area. Look for basic shapes. In this example imagine how the bones would be positioned. Based on what you visualize, use the Lasso tool to create your selection.

If you use the Gradient tool on your selection you would end up with results similar to this. Notice how light fades into the selection in a broad way from one direction to another? Practice creating subtle lighting with the Gradient tool.

This was created using a 100-pixel brush. The color is more concentrated along the central areas of the cut while other areas are not as clearly defined. See how the highlighted area fades back into the base tone?

If you add a secondary set of cuts and a few core highlight cuts you can begin giving the rendered art more contrast and depth.

Add rim lights (cool on the shadow side) to create the illusion that the fabric wraps around the leg behind what is visible of the figure in the drawing.

Tool Settings for Rendering the Hi-Fi Way

Before you start the lessons in this chapter, configure your selection and painting tools as follows. Keep these settings for all lessons in this chapter.

Review:

Installing the Hi-Fi Brush Presets

If you haven't already installed the Hi-Fi Brush Presets as directed on page 11, take a moment to do that now.

1 Configure the Magic Wand and Lasso Tools
Choose the same options for the Magic Wand and Lasso tools as you did for the flatting tutorials in the previous chapter. Set Feather to 0 pixels, set Tolerance to 0 and disable Anti-alias. This will create clean, crisp edges for all of your coloring.

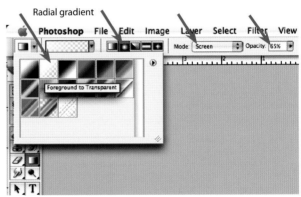

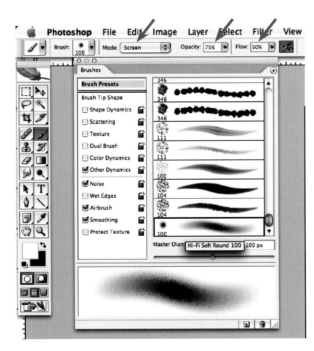

Radial gradient

2 Select the Brush Preset
From the Brushes palette, choose the Brush Preset named "Hi-Fi Soft Round 100." The options for this brush are preset so you can do your best rendering (see page 11 for more information).

To verify that you've selected the correct brush preset, double-check that the Brush mode is set to Screen, the brush opacity is 75%, and the brush flow is 50%.

3 Select the Gradient Preset
Select the Gradient tool from the Tools window, then choose the following options. With these settings, you'll be ready to paint with light the Hi-Fi way.

- *Shape: Radial.* This shape most closely resembles real light emanating from a source.
- *Color preset: Foreground to Transparent.* That means your gradient screen will gently transition from the chosen foreground color to nothing (transparent), allowing underlying layers to show through with no harsh edges.
- *Gradient mode: Screen.* Screen mode is explained on the facing page.
- *Gradient opacity: 65%.* With this setting, even where the gradient is the most dense, it will let some of the underlying colors show through so that objects appear bathed in light.

All About Screen Mode

What exactly is the difference between using Photoshop's tools in Normal mode and in Screen mode?

In Normal mode, you paint just like you would in the physical world. This means you have to select a new color each and every time you want to alter the shade of an object lighter or darker.

In Screen mode, you choose just one color for an object—we're going to call this the screen color. The screen color will act as a colored light affecting the object you are painting.

The more of the screen color you apply, the brighter the area becomes. This allows you to build up your light areas rapidly and realistically without having to constantly stop and select the next shade to use over and over again.

You will notice that there's a "Screen Mode" submenu within Photoshop's View menu. It's completely unrelated to the kind of screen mode we're talking about.

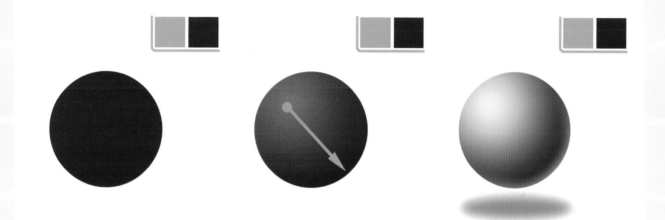

1 In the first image we have a circle filled with a dark green. This green is our base tone or base color. The two swatches in the upper right hand corner are the base tone and the screen tone or screen color. Using only the screen tone, we will create an infinite level of variations to the base tone.

2 Using the Radial Gradient tool set to Screen mode, drag the tool as indicated by the arrow. Notice how the circle starts to take on the subtle appearance of a sphere. This is because the screen tone realistically bathes the object in light just as a physical light source would.

3 If we apply the Gradient tool repeatedly, the highlight area will build up becoming lighter and brighter in a very natural, realistic manner. All of this can be achieved in only a few seconds with the Gradient tool and one screen tone. Think about how long this might take if you had to choose each individual shade of green needed to get the same effect in Normal mode.

We added a soft shadow under the final version of our sphere to make it look even more realistic. Compare this to the simple flat circle we started with.

endering a Sky

ow it's time to put what you've learned about making cuts to
ork. There are many ways to select and paint, but the basic
ocess is always to make a selection, then paint it with either the
ush or the Gradient tool. We'll begin with a sky.

Review:

Tool Settings

For all the lessons in this
chapter, be sure you've configured
your tools as directed on page 62.

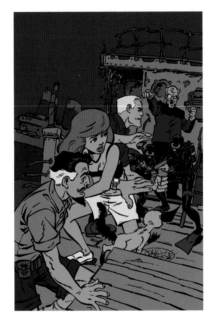

1 Select the Sky and a Sky Color

Open the Photoshop file for this
tutorial. This wonderful cover art for
The Terrifying Tales of Tommi Trek was
pencilled by John Byrne.

The finished, fully rendered piece is
on page 87; feel free to use it as refer-
ence as you work through each of the
lessons in this chapter.

2 Add a Gradient to the Sky

To start this background, choose
the Magic Wand tool and click on the
sky to select the sky. Next, select the
Gradient tool and select a light blue
(C50/M25/Y00/K00) from the Swatches
palette.

Make sure you didn't accidentally
deselect the sky. Click and drag the
Gradient tool from the bottom of the
sky upward. This will create a screen of
blue that starts out light at the bottom
and gets darker toward the top. If it's
not quite right the first time, Undo
the gradient and experiment with the
length of the drag until you like the
result.

3 Open the Hi-Fi Helper

Now it's time to take this background to the next level by adding the look of realistic clouds. Open the file Blue Sky 01.tif from the "Hi-Fi Helpers" folder on the CD-ROM.

4 Copy and Paste the Hi-Fi Helper Into the Sky

Make Blue Sky 01.tif the active document, if it isn't already. Choose Edit menu > Select All, then close the Blue Sky 01.tif file; now you're back in the original document. Make sure you haven't accidentally deselected the sky (if you did, select it again as directed in step 2). Now choose Edit menu > Paste Into. This command will drop the sky image inside the current selection.

5 Scale the Sky Image to Fit

Choose Edit menu > Free Transform. Handles will appear on the sky image. Drag them to scale and stretch the sky image to fill the area it was pasted into. Notice how the sky image does not overlap the ship or other elements on the page; it shows through only where you selected the original sky with the Magic Wand tool in step 2.

6 Adjust the Layer Opacity

In the Layers palette, set the mode of the sky layer to Multiply and adjust the opacity to a setting pleasing to you (50–65% opacity is usually a good starting point). Now you will see that the gradient you made is showing through the clouds, and the clouds themselves have blended with the background sky and taken on a darker overall appearance. The result is the look of subtle predawn light.

7 Flatten the Image

From the menu of the Layers palette, choose Flatten Image.

Review:

Color Temperature

Notice anything about the colors in this art? They use the warm-and-cool color theory you learned on page 56 to create depth. Cool blues in the background help the area to recede, while the warmer reds and oranges in the foreground appear to come forward.

Hi-Five

Congratulations! You've just used your first Hi-Fi Helper and created your first sky! You'll learn more about using all the Hi-Fi Helpers, as well as how to make your own helpers, in chapter five.

Rendering Basic Shapes

This lesson will introduce you to techniques for graceful rendering of two basic shapes: the cylinder and the box. Learn how to see and render the basic shapes within complex objects, and you'll be able to handle any subject.

1 Copy the Ship to a New Layer

Use the Magic Wand to select the various different-colored areas of the old steamship in the background. You will be using one screen color on all parts of the steamship at once, so it is OK to group these multicolored elements together into one selection.

Once you have all of the ship selected, choose Layer menu> New > Layer via Copy.

Pro Tip — Layer Via Copy

You can "draw" your cuts more freely when you move one portion of an image into a separate layer for rendering. To do it, select the area, then choose Layer menu > New > Layer via Copy.

Layer via Copy is safer than Layer via Cut. If you aren't happy with your first attempt at rendering in the new layer, you can delete it and start over with another Layer via Copy.

In this lesson, when you're done rendering in the new layer, we'll instruct you to flatten the image (i.e., make the entire image one layer). Then the rendered portion will effectively replace the original flatted one.

KEYBOARD SHORT CUT

Command-J (PC: Ctrl-J)

Copies the current selection into a new layer. Equivalent to choosing Layer menu > New > Layer via Copy.

2 Name the Ship Layer and Turn On Lock Transparency

Double-click the new layer, Layer 1, in the Layers palette and rename it "Ship."

Click the Lock Transparency button on the Layers palette. (Be sure the little padlock icon appears on the layer named Ship.) Lock Transparency is like an invisible force field around the empty area surrounding the object you want to render. For an in-depth explanation, see the previous page.

Notice that the cuts go past the top edges of the smokestacks and into the sky. Remember, thanks to Layer via Copy (step 1), the sky is not really part of the selection; it's on a different layer. And because of Lock Transparency (step 2), you can lasso a cut past the edges of an object without fear of changing the surrounding areas.

3 Make the Core Highlight Cuts in the Smokestacks

Use the Lasso tool to make selections, or "cuts," on the smokestacks as shown here. We'll use these cuts to create highlights in a moment. It's OK if making the cuts feels unnatural at first. Don't worry about making them perfect the first time. Once you get used to the technique, you can always come back later and revisit areas you want to improve.

Review:

Adding Cuts

As you learned on page 61, the process of selecting an area and then painting it is called *adding cuts*. From now on, when we tell you to add cuts, we mean the two-step process of selecting an area with the Lasso tool and then painting it with the Brush tool.

4 Brush a Highlight Through Each Cut and Lasso the Secondary Cuts

Use the Color Picker to choose a soft blue. Select the Brush tool and be sure its settings match those in step 2 on page 62. Drag the brush through each cut to create central highlights on the smokestacks. It may take a few tries to get the subtlety just right; experiment with the brush size.

Lasso a new set of cuts larger than the first ones, as shown. Use the Color Picker to choose a soft blue such as C72/M36/ Y00/K00.

5 Brush Secondary Cuts, Then Select Rim Light Cuts

Once again, drag the Brush tool through the selections to partially fill the cuts with the blue screen tone. Choose a deeper blue such as C100/ M75/Y00/K00.

Make selections for rim light cuts on the leading edges of the smokestacks.

6 Finish the Rim Lights

Brush the same blue as you used in step 4 through the cuts on the leading edge of the smokestacks. Choose a deeper blue from the Color Picker and add cuts to the trailing edges of the smokestacks.

Review:

Basic Shapes

Do these smokestacks remind you of anything? Exactly. These smokestacks are essentially two cylinders (see page 58). Nothing to be intimidated by at all.

7 Find the Next Shapes

Now that you're thinking about shapes, what do these next two parts of the ship look like? A couple of boxes, right?

8 Add Base Cuts to the Superstructure

Switch back to your original soft blue from step 4 and add a couple of wide cuts covering lots of area to define the front plane of the box shapes.

Focusing on the same central area, add a couple of squiggle-shaped base cuts. When you drag the Brush tool through the cuts, keep the center of the brush aligned with the center highlight cut on the smokestack above. It will tie the two highlights together so that the smokestacks and box shapes work together to help convey the concept of one ship.

9 Finish With Secondary Cuts, Then Flatten

Add secondary and then core highlight cuts using the deep-and-light blue screen tones until your ship resembles our example. When you are done with the ship, choose Layer menu > Flatten Image.

Lock Transparency

With the Lock Transparency layer option, you can render objects quickly and with a more natural look. Plus, you'll minimize the amount of time you spend making and remaking cuts. (In some versions of Photoshop, this option is called Preserve Transparency.) The button looks like this:

1 Copy the Flesh to a New Layer

For this example use the Magic Wand tool to select Tommi Trek's flesh. Next, use Layer menu> New > Layer via Copy to place only the flesh on a separate layer. Imagine, as we've visualized here, that Tommi's flesh (shown in orange) is floating on a separate layer above the rest of the artwork.

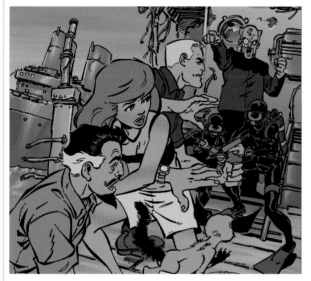

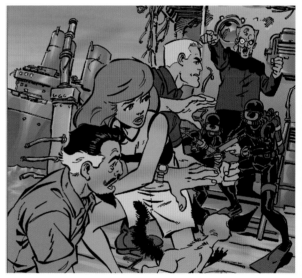

2 Lock Transparency, Then Paint

Next, click Lock Transparency in the Layers palette to enable that option for the new layer. This protects transparent areas of the layer from being altered.

Paint across and beyond the flesh area using an artistic, natural brushstroke motion. Because Lock Transparency is enabled, the stroke shows only within the flesh area.

3 Compare to Results Without Lock Transparency

For the sake of comparison, this is what happens if we paint freely over the area without first enabling Lock Transparency.

If this cool Lock Transparency option wasn't available, you would have to do one of two things:

- Select the flesh with the Magic Wand, then paint across the area. Sure, if you make a mistake, you can use Edit > Undo to backtrack, but if you lose your Undo path back to the original selection, you've got to select the flesh all over again.
- Confine your brush movements to the flesh area (and settle for cramped, awkward-looking strokes).

Save yourself some time and get more natural-looking rendering with this Life Saver!

endering Water

ery colorist has certain subjects they find particularly challenging render, such as feet or noses. Water is a very common source of xiety for colorists. We're going to show you how to find the basic apes in water, and we have a Hi-Fi Helper from the CD-ROM that ll give your water that extra-special touch.

Review:

Tool Settings

For all the lessons in this chapter, be sure you've configured your tools as directed on page 62.

1 Add a Gradient to the Water

Use the Magic Wand to select the water beneath the ship. Select Layer menu > New > Layer via Copy. Name the layer "Water" and use the Gradient tool to grad in some light blue screen tone from the bottom to the top.

VOCABULARY:
Grad

Short for "gradient." When we say "grad some blue into the sky from bottom to top", we mean pick a color, select the sky area, and apply the Gradient tool to the sky by clicking it at the bottom and dragging toward the top.

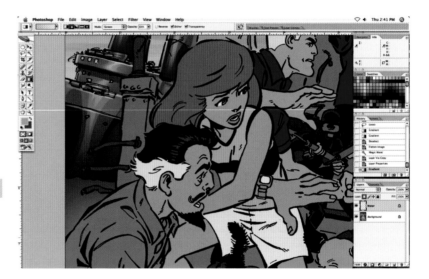

2 Add Cuts to the Water

Add cuts to the water layer (using the Lasso and Brush technique) until your water resembles ours. Notice the waves resemble cones or pyramids— easy shapes that you can render (see page 58). Use a squiggly cut to create a visual pathway from the big waves toward the bottom edge of the water. This will help define the surface plane of the water and guide the viewer's eye back into the composition.

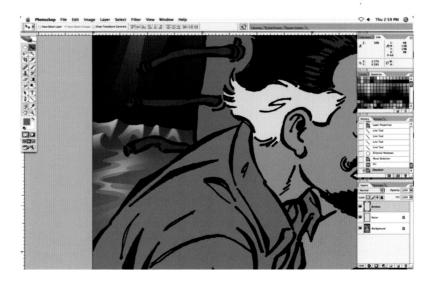

3 Load the Water Transparency Selection

Choose Select menu > Load Selection, then choose "Water Transparency." The result will be an active selection around the water. (For more about loading selections, see the Pro Tip below.)

 Loading Selections

Here at Hi-Fi we've learned a little trick buried within Photoshop to quickly make a selection from the contents of a layer. The trick is to go to the Layers palette and Option-click the layer (on a PC, it's Alt-click).

This neat feature tremendously speeds up the use of Hi-Fi Helpers because you don't have to use the Lasso or Magic Wand tools to make the selection.

To achieve the same results you can also choose Select menu > Load Selections. The resulting dialog box will let you load a selection by choosing from a list of available Layers and Channels.

KEYBOARD SHORT CUT

Option-Click (PC: Alt-Click)

You can combine the two-step process to load selections in step 3 into a single step. While holding down the Option key, click the icon for the artwork in the Layers palette.

4 Open the Hi-Fi Helper and Copy the Image

Use a Hi-Fi Helper to put the finishing touch on your water. Open the Hi-Fi Helper named Water 01.tif, located on the CD-ROM under "Hi-Fi Helpers." Choose Select menu > All, then choose Edit menu > Copy. Close the file Water 01.tif.

5 Paste the Hi-Fi Helper Into Your Water

Make sure the selection you loaded in step 3 hasn't accidentally been deselected, then choose Edit > Paste Into. The Hi-Fi Helper image is pasted in, but it's visible only in the area you had selected: the water.

Choose Edit menu > Free Transform and use the transform handles to position and scale the Water 01.tif file until it fills the water area. In the Layers palette, set the Layer mode to Screen, and your cuts will become visible.

6 Adjust the Layer Opacity, Then Flatten

In the Layers palette, adjust the Opacity of Layer 1 as needed. A setting of 35% looks about right.

Choose Layer menu > Flatten Image.

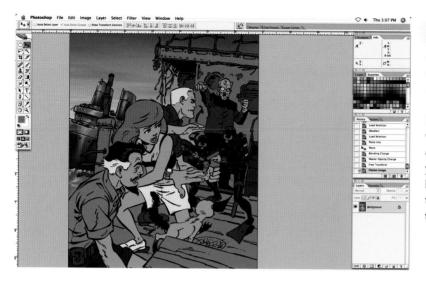

Sit Back and Admire

Good work! You have used the concepts for rendering simple shapes such as boxes, cylinders and cones to render a complete background.

Don't worry if your image doesn't look exactly like ours. As an artist you will bring your own unique vision to every project. The more experience you gain, the more comfortable you'll be with the tools and techniques, and the more control you will have over the finished image.

LIFE SAVER

Hi-Fi's Four Steps for Successful Rendering

1 Select the Object
Select the object for rendering with the Magic Wand.

3 Add Cuts
Add cuts using the Lasso tool followed by either the Brush or the Gradient tool. (At Hi-Fi, we generally use the Brush more on figures or faces, and the Gradient tool more on large areas such as backgrounds.)

2 Isolate the Object
Isolate the object using Layer via Copy and Lock Transparency.

4 Flatten the Image
Flatten the image to merge all of the layers.

Rendering Box-Shaped Objects

In this lesson, we'll use the Hi-Fi four-step process (summed up on the previous page) to render the boat.

Review:

Tool Settings

For all the lessons in this chapter, be sure you've configured your tools as directed on page 62.

1 Define the Light Side of the Pillar
Set your foreground color to C25/M40/Y75/K00 then add a base cut to define the light side of the box-shaped pillar in front of the old steamship. Start with a brush size of 100 pixels and use the square bracket keys to adjust the size until you get the results you want. No one brush size can accomplish all tasks, so adjusting and experimenting with different sizes is a good habit to start.

Review:

Rules of Light and Shadow

This piece of art uses the rule of light and shadow (see pages 56–57) that states that the parts of an object that are in shadow are generally cooler in color than the sunlit portions. You'll notice in step 2 that we create a cool greenish cut on the shadowy side of the pillar, in contrast to the warmer tan base color. This adds depth and realism to the image.

There's another rule of light and shadow at work in this image, too. Can you tell which one it is?

2 Finish the Cuts on the Pillar
Add a cooler cut to the shadowy side of the pillar using the same screen tone as step 1, followed by a narrow cut on the light side of the pillar next to the ink line. This will be your core highlight cut for the pillar. This really defines the edge and makes the pillar start to jump off the page. Add rim light cuts to the light side of the pillar to finish it.

3 Render the Cabin

Move on to render the cabin of the boat, just behind Baron von Bloc and his frogmen. Compare our example here with the unrendered cabin on page 75.

Start with a base cut that treats the cabin as a large boxlike structure. You might want to use a larger brush size to spread the light out evenly on the larger sections. Then adjust your brush size down and add smaller detail cuts.

This is a good time to start thinking about the style of your cuts. The worn metal of the ship's walls will have different surface properties and reflectivity than the wooden decking or the glass in the porthole. Just by changing the shapes and sizes of your cuts, you could make the ship look either shiny and new or well-worn and used. Observe and think about what the artist intended, and then attempt to deliver what the art is asking of you.

Pro Tip Imagine Your Scene in Three Dimensions

Always keep in mind where your imaginary light source is coming from. You want to create a consistent and believable environment for these characters to live in. Imagine the scene as a movie set, and imagine how the light source would fall across the set, bathing certain areas in light and leaving other areas in darkness.

LIFE SAVER

You Don't Have to Render Every Surface

The amount of area you leave unrendered affects the overall look and feel of the scene. These unrendered areas are just as important as the areas you decide to cut and screen. Let the shadows do some of the work for you.

endering Cylinders

t's move on to the cylindrical foreground elements: the railings
d the porthole. Remember to use the Hi-Fi four-step rendering
ocess, which is summed up on page 75.

Review:

Tool Settings
For all the lessons in this
chapter, be sure you've configured
your tools as directed on page 62.

1 Isolate the Broken Rail

Start by using Layer via Copy
and Lock Transparency to isolate the
large broken rail sticking out of the
top of the pillar and to protect the
surrounding areas.

Review:

**You Can Select
Beyond the Edges**
Remember, thanks to Lock Transpar-
ency (see page 68), you can lasso
beyond the edges of the object
you're rendering. This lets your
strokes be more fluid and natural.

2 Render the Rail

Add cuts to the broken rail. On a
cylinder, the core highlight needs to be
on the center point of the cylinder—that
is, the point that would be closest to the
viewer if the railing were a real physical
object.

Next, add rim light cuts to match
those on the pillar. (The rail and pillar
should have similar rim lights because
they are located in the same plane of
the scene and have the same positional
relationship to the light source.)

Preview:

Keeping Highlights Consistent
Sunlight comes from a source that is always
moving. So, when you give two sunlit objects the same
highlights, you are effectively tying them together in
space and time. The highlights in a sunlit scene must be
consistent, or your art won't be believable.

3 Render the Three Small Rails

Now, move on to the three little broken rails, and add all the needed cuts to them (base cuts, secondary cuts, core highlights and rim lights).

4 Render the Top Railing

Complete the rendering on the rest of the rails, using the same methods as in steps 2 and 3.

5 Render the Porthole

Using Hi-Fi's four-step process, render the porthole's glass and frame. Render the different elements of the porthole's frame carefully to give it dimension and thickness, while keeping the light direction in mind.

Have you rendered everything on this layer that you intended to? See the Life Saver on this page.

LIFE SAVER

Check Your Work by Hiding the Background

It's easier to see what elements you have left to render in the layer you're currently working on if you toggle the background layer on and off (by clicking the eyeball in the Layers palette). You'll feel foolish if the book is printed and one of your pages has a big, unrendered chunk of solid base tone in it. (Yes, it has happened to us.)

Pro Tip Be Willing to Make Decisions

It isn't always obvious from the artwork or the story line what objects on a page should look like. Part of your job as the colorist is to make decisions and execute them with a confidence that convinces everyone that you are right. The porthole glass is an example. We made ours look convex, but you could make yours flat and your version would be just as correct as ours.

Rendering Weathered Wood

With careful rendering of the deck, you can achieve the look of separate planks and create a wood-grain appearance.

Review:

Tool Settings

For all the lessons in this chapter, be sure you've configured your tools as directed on page 62.

1 Make Shadows Along the Boards

Set the foreground color to a deep golden tone such as C30/M55/Y100/K00, and choose a larger brush weight (we're using 600).

The planks are essentially rectangles stacked side by side. Gaps between the planks create long, skinny shadows, so add long, skinny cuts along the lines between each plank. (They're subtle— look closely around the characters' feet.)

2 Add Squiggly Cuts

Reduce the size of the Brush tool until it is slightly larger than the width of a plank, and add a series of squiggly cuts using a color slightly lighter than the base color of the planks. These will create the look of wood grain and also define a visual pathway between Dr. Trek at the bottom of the page and Baron von Bloc on the steps.

3 Render the Escape Hatch

Use the same techniques in step 2 to render the escape hatch Dr. Trek is opening for Tommi to escape. Remember the Rules of Light and Shadow from pages 56–57? Make the colors on the escape hatch a little warmer and lighter than those on the deck to help bring the hatch forward in space. After you render all the deck boards on the layer, remember to flatten the image before moving on to the next lesson.

Square Brackets

The left square bracket ([) reduces the brush weight, and the right bracket (]) increases it.

Rendering figures

Human figures are constructed of basic shapes like anything else, but the skeleton, muscles and skin under clothing add complexity to the contours.

1 Add Base Cuts to the Arm and Leg

Select Dr. Trek's arm and leg skin with the Magic Wand tool and isolate it on a layer named "Flesh."

Set the foreground color to C00/M63/Y68/K00. This is the primary screen tone you will use to render the skin tones on the page.

Now add base cuts to the center of Dr. Trek's arm and leg. Leave the flat color in the area just below his shirt sleeve to create the impression that the shirt sleeve is casting a shadow on the arm. (You can leave the same kind of shadow where the leg meets the shorts.)

LIFE SAVER

Figure Rendering Tips

- Always work from the general to the specific. For example, get the basic light direction down on the head, limbs and torso before you start refining smaller areas such as the nose, feet and hands.
- Keep the entire figure in mind even when you are working on a specific area, such as an elbow or a foot. Don't paint yourself into a corner by spending too much time on a specific area only to realize what you have done does not work with the figure as a whole.
- Look at figures in magazines, books, and other comic books to develop a sense for how the human figure is put together and how all the parts work as a unit.

Pro Tip Basic Shapes in Arms and Hands

As you add the cuts to the arm, remember to look for spheres, cylinders and box shapes in it.

- An arm is like two cylinders joined by a small sphere at the elbow. The highlight should show the center of the cylinder, like the railings on page 79.
- Fingers are a series of cylinders that join to the back of the hand—which can be treated as a partial sphere, since it's somewhat fleshy and rounded.

2 Add Secondary Cuts to the Arm and Leg

Add a second, lighter set of cuts for the center highlight along the arm and fingers.

3 Add Rim Lights

Add rim light cuts to the arm and leg. Use C72/M54/Y00/K00 for the rim lights on the cool side (the side facing away from the light source).

4 Render the Left Arm and Begin the Face

Render Dr. Trek's left arm in a manner similar to the right, making sure to keep the light source consistent with the rest of the page.

To start on the head and neck areas, visualize Dr. Trek's head and neck as a box sitting on top of a cylinder. Use the Lasso tool to make a cut that defines the side of the face as the light area. (Leave the front of the face in shadow to be consistent with the lighting elsewhere on the page.)

5 Finish the Face and Start the Shoulder

Add a second set of highlight cuts to Dr. Trek's face and finish the face with rim lights.

For Dr. Trek's shirt, envision the shoulder as a sphere and the shirt sleeve as a cylinder. Using C15/M60/Y94/K00 as your screen tone, add a series of cuts to give shape to the shoulder and arm under the sleeve and to help define the folds in the fabric.

6 Finish the Shoulder and Collar

Follow up your first set of cuts on the body of the shirt with a second set that falls entirely within the first. Do not let the inside cuts extend beyond the outside ones; any overlapping will spoil the look.

Add two sets of cuts to the collar, using the neck as a guideline for placing the highlights.

7 Add Cuts to the Torso

Add a series of cuts to define the torso and give depth to the folds in the fabric. Finish the shirt with a few warm and cool rim lights.

Start the Shorts

Add cuts to the shorts, visualizing the legs as cylinders. Be sure these highlights tie into the highlights you have created on Dr. Trek's shirt. The overall impression should be of one continuous highlight that goes down the side of the torso, down the leg of his shorts, and on to the visible part of the leg.

Finish the Shorts

Add the secondary cuts and rim lights to complete Dr. Trek's shorts. Merge the layer with the shorts into the background layer by pressing Command-E (PC: Ctrl-E).

Render the Belt

Set the primary screen tone to C22/M70/Y81/K46. Add base and secondary cuts to the belt to complete Dr. Trek's outfit. Make the belt buckle a different color to help it stand out.

Hi-Five You've rendered your first figure. Whew, that was exhilarating!

11 Render the Next Figure

With Hi-Fi's four-step process (see page 75) you can now render Tommi Trek's flesh, then her hair, shirt, shorts and shoes. Try rendering her on your own, without specific instructions. If you get lost, you can look back at the step-by-step instructions for Dr. Trek.

Remember to keep the light direction in mind while rendering each part of the figure so that it will be a cohesive unit when you are finished.

12 Render the Bodyguard and the Cat

Once you have Tommi Trek rendered, move on to her cat, Chance, and her bodyguard, Chase.

Need Help Choosing Screen Tones?

You are probably getting the hang of choosing screen tones for skin, but if you want help, you can use the screen tones in the Hi-Fi color palette provided in the "Hi-Fi Helpers" folder on the CD-ROM. (See page 11 for instructions if you haven't already installed them.)

Hi-Five
You're doing great! It's important to push yourself to render more and more subjects without specific instructions. The more you do on your own, the more your confidence will grow. The Hi-Fi four-step process for rendering will soon become second nature.

If you encounter an unfamiliar object, such as the frogman's flippers, do not be afraid. Part of your job as a colorist is to make decisions about how things should look in color and then convince the viewer you are right.

13 Render Baron von Bloc

Move on to Baron von Bloc. When making cuts on his shirt, don't get too carried away adding wrinkles to the fabric. You want to make sure the underlying form is clear to the reader. A suggestion of detail is enough.

14 Render the Frogmen

Work on the villainous frogmen. Their wetsuits have a lot of heavy black ink, so you may need only one cut in each colored area to bring out the central highlight. Put the highlights on the shoulders, arms and legs, then use those as your guide for adding highlights on shoulder straps, wrist weights and so on. For the fins, make the first cut broad to define the flatness of the fin, then use the second cuts to indicate their webbed nature and slip-on design.

Remember to flatten the layers and save your file before closing it.

Preview:

Color Holds, Effects and Separations

Wow. You've done it. You've rendered a comic page (a piece of John Byrne artwork, no less). But wait—you're not ready to frame and hang it on the wall just yet. In the remaining chapters, you will learn the secrets to color holds, special effects, glows and finally color separations—everything you will need to take your comic book coloring to the professional level and beyond.

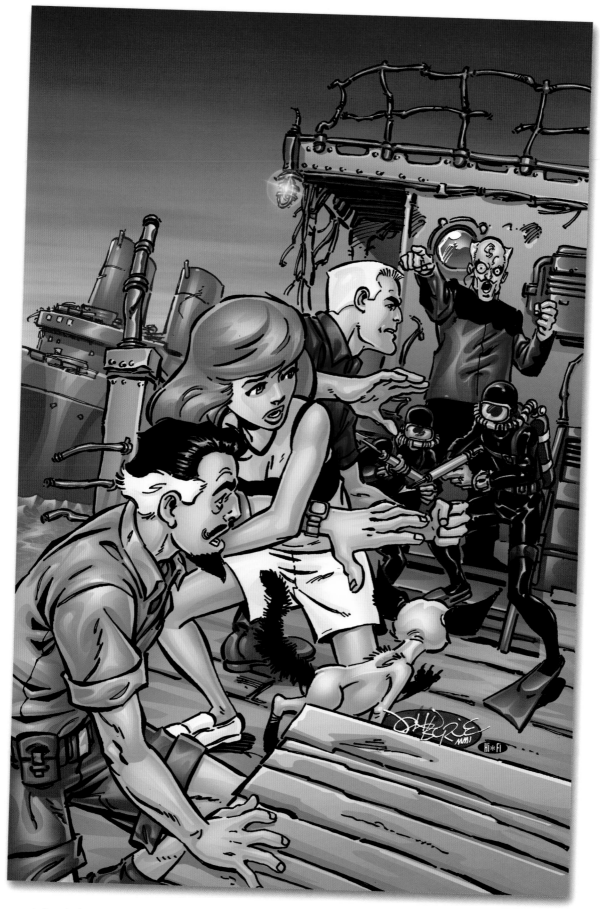

Finished Piece
Use this completed color piece as reference when rendering
your version. Visit www.hifidesign.com and learn how to
submit your version to the *Hi-Fi Color for Comics* Members Area!

COVER IMAGE, *THE TERRIFYING TALES OF TOMMI TREK* #2
Art by John Byrne
Color by Hi-Fi

Homework

For homework answers, visit www.hifidesign.com.

Assignment 1:

Quiz

Let's test what you've learned from this step-by-step section with a short quiz. Find the answers at www.hifidesign.com—no peeking!

1. You often have to determine where the light source is based from what the artist has given you. Based on what you've learned, where are the light sources coming from on the following image?

 A. To the right and above.
 B. To the left and above.
 C. To the left and below.
 D. None of the above.

2. In this chapter you learned Hi-Fi's four steps to successful rendering. Put the steps in the correct order:

 A. Flatten image to merge all layers.
 B. Select the object with the Magic Wand.
 C. Add cuts using the Lasso and Brush tools.
 D. Isolate the object using Layer via Copy.

3. What does Photoshop's Screen mode mean?

 A. Painting with texture.
 B. Painting with color.
 C. Painting with light.
 D. Painting with your fingers.

4. Which of the following is *not* associated with the term "cut"?

 A. Old timers cutting Rubylith masking film.
 B. Airbrush artists cutting selections from frisket.
 C. Using the Lasso tool to select an area.
 D. Checking Lock Transparent pixels.

5. Which two steps can be combined into what single keyboard command to select and isolate an object?

 A. Cut and Paste can be replaced with Layer via Copy.
 B. Cut and Paste can be replaced with Merge Layers.
 C. Lasso and Magic Wand can be replaced with Eraser.
 D. Control, Alt and Delete can be replaced with the power switch.

6. What do the bracket keys allow you to do in Photoshop?

 A. Change the layer opacity.
 B. Change the zoom percentage of the active window.
 C. Change the color of the brush.
 D. Change the size of the brush.

Extra Credit

Imagine that after all your hard work rendering that cover for *The Terrifying Tales of Tommi Trek*, your editor comes back and tells you that the setting is supposed to be the North Pole at high noon. How will this change your finished piece? Obviously, you'll have to change the color of the sky and maybe that of the water, but how will the new setting affect the rest of the page? Practice making changes to your page. Then try re-envisioning the page in other ways, solely through your use of coloring.

OPPOSITE PAGE, *WIZARD WORLD PHILLY CONVENTION SPECIAL COVER*
Spider-Man™ ©2007 Marvel Characters, Inc. Used with permission.
Art by Joe Quesada
Color by Hi-Fi

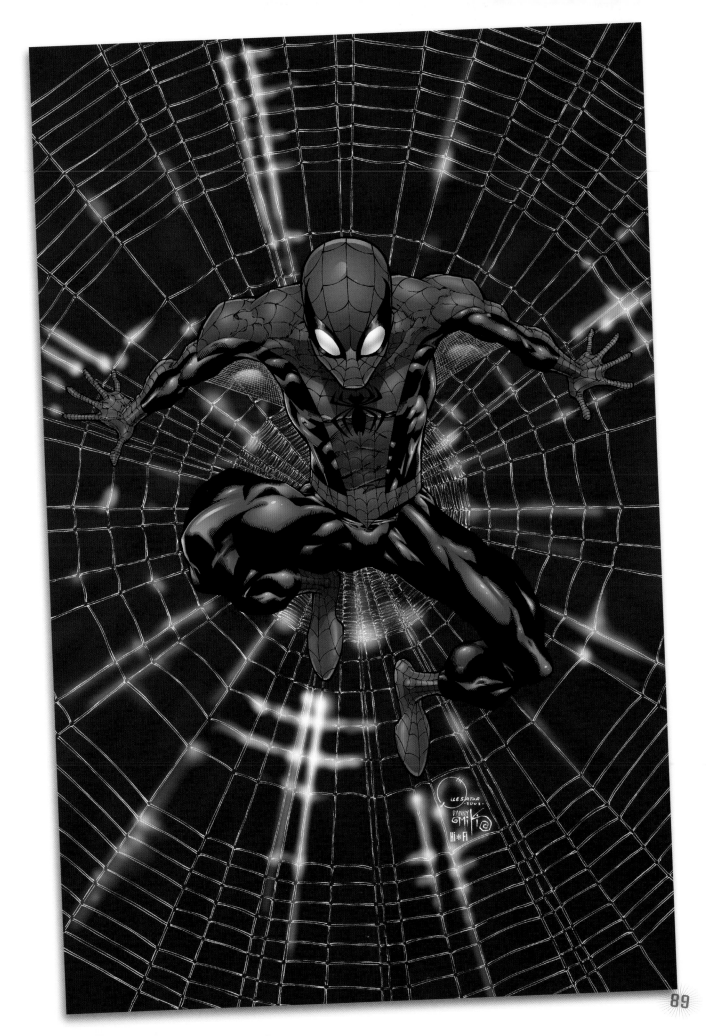

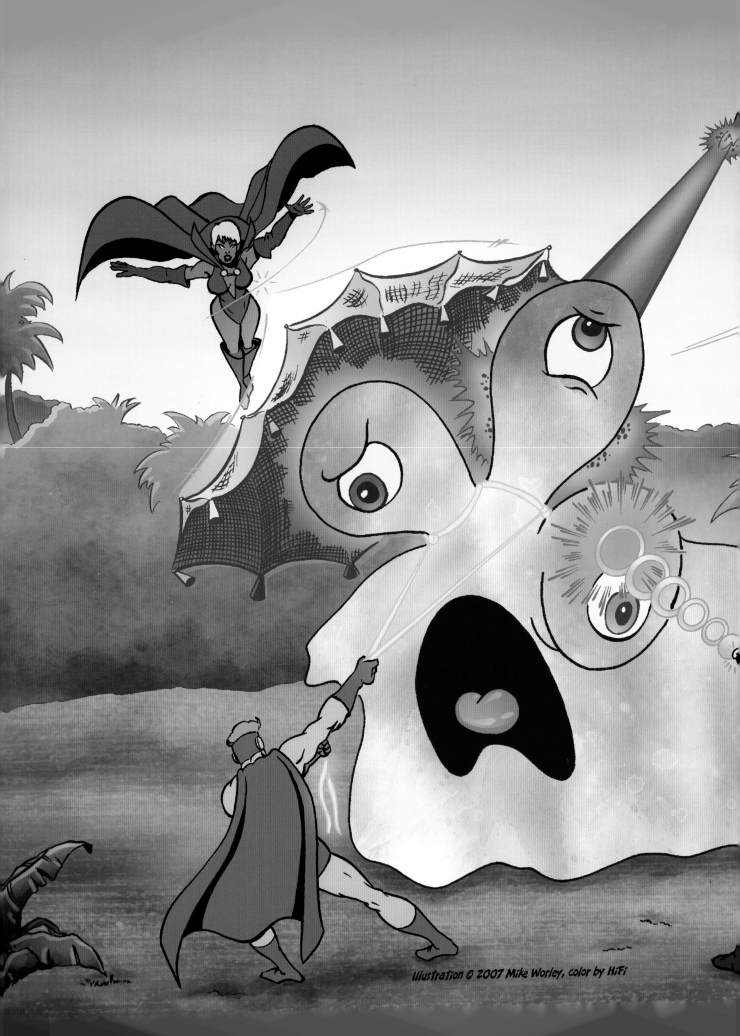

Illustration © 2007 Mike Worley, color by HiFi

Color Holds

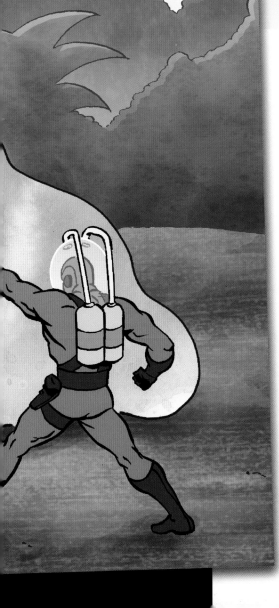

In this chapter you will learn how to lasso line art, wrangle pencils and knock out inks to perform color holds. Yee-haw!

Color holds, sometimes referred to as knockouts, are made by turning portions of the black-and-white line art into a color. In this chapter you will learn the ins and outs of color holds, how to use a Hi-Fi action to layer your holds, and—best of all—all types of cool effects you can achieve using color holds.

CAPTURING THE COLOR MONSTER
Art by Mike Worley
Color by Hi-Fi

Color Holds

A *color hold* is when some of the black lines in a drawing are changed to another color. Other terms you might hear that mean the same thing are *knockout* and *redline*. The black lines can be made the same color as the filling of the shape, effectively making the lines disappear. The lines can also be made a contrasting color. The choice depends on what effect you want to achieve.

So why would you want to do a color hold?

For effect. Maybe your hero has a blue ring with special powers, and the artist drew a burst emanating from the ring. As the colorist, you can turn the lines of the burst from black to vibrant blue to emphasize the ring's power.

To create depth. If you do color holds for the background elements while keeping the foreground lines

Transparent Objects
Color Holds: A darker shade of the color of the transparent object, in this instance, amber.
Color Rendering: Slightly faded and affected by the color of the glass.
Effect: Creates depth, reflection and sheen to help the viewer believe something solid is directly behind the transparent object.

Nearby Figures/Objects
Color Holds: Deep and muted yet lighter than solid black.
Color Rendering: Muted, low-contrast.
Effect: Establishes hierarchy in the plane of view creating depth and maintaining focus on the central figure.

Energy
Color Holds: A bright, saturated color slightly darker than the energy itself.
Color Rendering: Bright, colorful, high-contrast.
Effect: Gives the viewer the sensation that the energy is blasting into the viewing plane away from the figure.

Distant Objects/Figures
Color Holds: Very muted.
Color Rendering: Muted colors with less contrast in the rendering.
Effect: Creates the illusion that these objects are pushed into the background therefore distinguishing the foreground objects more clearly.

DIGITAL WEBBING PRESENTS #34: THE ENIGMAS
Story by Dustin Yee
Art by Casey Maloney
Color by Hi-Fi

Central Character
Color Holds: None.
Color Rendering: Normal colors, not muted or faded.
Effect: Viewer's eye is drawn to the prominent color and solid black linework. Figure appears to be closest to the viewer in the foreground plane.

solid black, the background appears more distant. (Sometimes you can create a powerful effect by doing it the other way around.)

To communicate the presence of something transparent. Imagine that the artist has drawn a shot in which the reader sees from the vantage point of a character in a car looking out through the windshield. You might use color holds for everything beyond the glass.

To create focus. Say you're coloring a battle scene with hundreds of soldiers, and you need the reader to notice one soldier who has been shot. By changing the lines around the blood from black to blood-red, the reader's eye will be drawn to that spot on the page.

Review:

Atmospheric Perspective

You'll recall from the Rules of Light and Shadow (see page 57) that objects in the distance appear lighter and duller in color, a phenomenon called atmospheric perspective. That's why color holds in the background work so well to create depth.

In the art on the facing page, the use of color holds and muted colors on the foreground gun barrels is actually contrary to the principle of atmospheric perspective. So why does it work? Maybe those muted foreground colors mimic the way our minds and eyes work together: We pay more attention to whatever our eyes are focused on and less attention to objects in our peripheral vision.

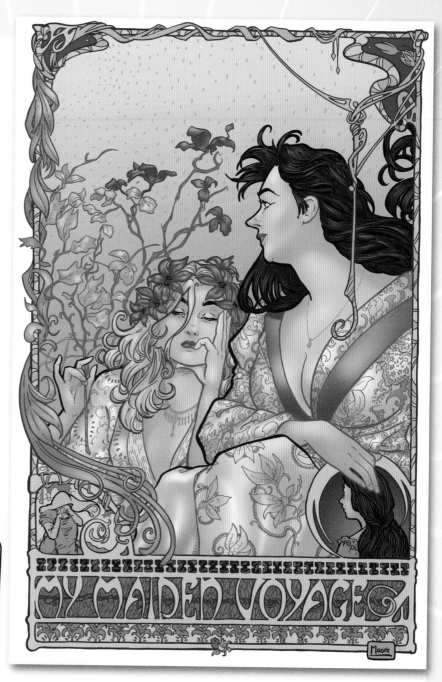

Color Holds to Emphasize Lines
When the color of the line is the same as that of the object, the line disappears. The opposite strategy—making the lines a contrasting color—creates a less realistic, more stylized look. Terry Moore's cover for *Strangers in Paradise*, vol. 3 #51 was inspired by the work of Czech illustrator, Alphonse Mucha (1860–1939). Here the colorist used holds nearly everywhere to emphasize the flowing, organic lines.

Creating a Color Hold

Hi-Fi Color Hold Action #1: "Make Holds Layer w/ Line-Art"

Now that you know what a color hold is and have seen some of the interesting ways they can be used, you're probably thinking of ways to use them in the images you color. On the CD-ROM we've provided a set of Photoshop actions to make color holds easier.

The Hi-Fi Color Hold Actions create a temporary layer containing the visual information from your file's Line-Art channel. Some things to know:

- To avoid problems and confusion, before running this action, be sure to flatten your image so that it has only a background layer.
- After you run the action, you'll have your line art in a Holds layer where you will be able to colorize it.
- Do not flatten your image while you have a Holds layer. Once you have a Holds layer it will stay above your Background layer until you make your final color separation file.

1 Run the First Color Holds Action
Load the Hi-Fi Color Holds Actions following the CD-ROM installation instructions on page 11. Open the artwork you want to make color holds for. (In our example, we're going to do a color hold on the grass behind the alligator.) Click the green "Make Holds layer w/ Line-Art" button in the Actions palette to run that action.

2 Make "Holds" the Active Layer
When the action is done you will have a layer named "Holds." Check the Layers palette to make sure Holds is the active layer (it should be highlighted blue). Stay on this layer for the rest of the lesson.

Review:

Lock Transparent Pixels

Notice in step 2 that the Holds layer has Lock Transparency enabled. With this option, you can include transparent areas of the Holds layer in your selection, yet the color fill you apply in the next step will change only the line art, not the empty parts of the selection.

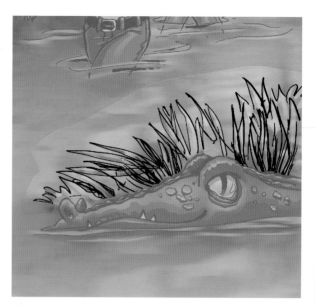

Pro Tip — Quick-Mask Mode

In step 3 we're using Photoshop's Quick-Mask mode. The areas tinted red are outside of the selection. When we made cuts in chapter three we did not use Quick-Mask mode because you would most likely have found it distracting and confusing. For complex color holds, though, this mode is helpful. It is easy to become confused or lost while making selections for color holds. Quick-Mask makes it very clear what it selected and what isn't.

3 Lasso the Lines You Want to Hold

Use the Lasso tool (with Feather set to 0) to select the areas of line art you want to change from black to a color.

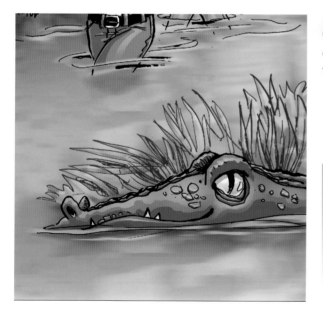

4 Color the Lines

Use the Color Picker to select a color for the grass lines. Choose Edit menu > Fill to fill the selected area with the foreground color.

**Option-Delete
(PC: Alt-Delete)**

Fills the selected area with the foreground color.

Pro Tip — Choosing the Color for a Color Hold

As you know from page 93, color holds are good for pushing an element back in space. To accomplish this, choose a color for the lines that is only slightly darker than the color of the fill. High contrast attracts the eye, so your goal is to reduce the contrast of the element you want to push back.

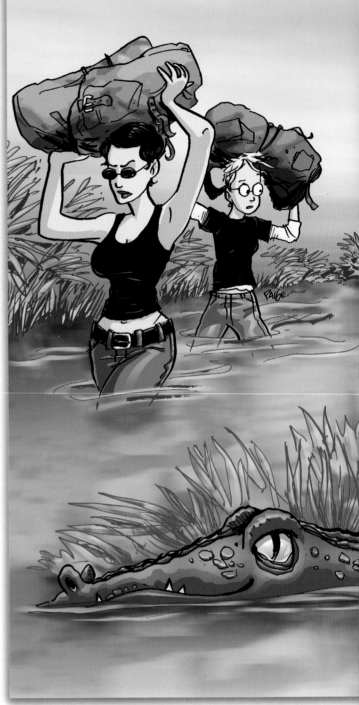

5 Finish Holds

When you're finished with all the color holds, click "Finish Holds" in the Actions palette.

Finished Art

The color hold on the background grass not only pushes the grass back into space but also keeps the focus on the central characters.

COVER IMAGE, *JANE'S WORLD* VOL. 9
Art by Paige Braddock
Color by Hi-Fi

Preview:

Special Effects and Color Separations

Per the order of the chapters in this book, the steps in coloring are: flatting, rendering, color holds, special effects, and finally, color separation.

Advanced Color Holds

In the previous lesson you tried your hand at basic color holds. Are you ready for something a bit more complicated?

Remember in the flatting chapter how you learned to flat the largest areas first, then flat progressively smaller areas? You also learned how to avoid making the same selection twice by using the Magic Wand tool to subtract portions from a loose selection. You will use these same basic principles here to make quick work of what could be a time-consuming color hold scenario.

In this aerial view panel, Loch Mo from *The Enigmas* is stretching his head and tail high above the ground. We're going to use color holds to add to the illusion of depth in this panel.

1 Run the First Color Hold Action, Then Lasso the Area to Be Held

Open the file Enigmas_400_11.psd from the CD-ROM under Lessons > Chapter 4. Click the green "Make Holds layer w/ Line-Art" button in the Actions palette (explained in the previous lesson, page 94) to run that action. When the action is done, check the Layers palette to make sure "Holds" is the active layer (it should be highlighted blue). Stay on this layer for the rest of this lesson.

Use the Lasso tool (with Feather set to 0) to select the area you want to color hold. Here, we've selected the lines that make up the ground-level parts of the scene. We've used Photoshop's Quick-Mask mode to make the selected area easier to see. (Everything tinted red is outside of the selection.)

2 Color the Lines

Use the Color Picker to select a color for the lines. Choose Edit menu > Fill (or press Option-Delete) to fill the selected area with the foreground color. Choose Select menu > Deselect to drop the current selection.

Sidewalk and characters
loosely selected

Review:

Positive (+) Selection Tools
Remember that holding down the Shift key while selecting adds the next selection to the current one.

Selection minus black

3 Add More Colors to the Hold
Use the Lasso tool again to make a loose selection. (In our example, we've selected the sidewalk and the characters standing on it.) Use the Color Picker to select a new color. Choose Edit menu > Fill (or press Option-Delete) to fill the selected area with the foreground color. Choose Select menu > Deselect to drop the current selection.

Review:

Negative (-) Magic Wand
For a speedy selection, remember that you can select directly through black areas, then use the negative Magic Wand with Contiguous unchecked to remove the black from the selection.
For a speedy selection, remember that you can select directly through black areas, then use the negative Magic Wand with Contiguous unchecked to remove the black from the selection.
To make the Magic Wand negative, hold down the Option key (PC: Alt key).

4 Add Remaining Holds
Repeat step 3 to add more color holds until you have completed your holds (see art on next page). We added separate colors for each of the figures on the sidewalk.
When you're finished with all the color holds, click "Finish Holds" in the Actions palette (this action is explained on page 96).

FROM *DIGITAL WEBBING PRESENTS #34: THE ENIGMAS*
Story by Dustin Yee
Art by Casey Maloney
Color by Hi-Fi

Finished Art
Color holds can not only create incredible depth within a single
panel, they can also help guide the reader's eye from one panel to
the next.

For homework answers, visit www.hifidesign.com.

Assignment 1:

Use Color Holds to Show Motion

For this homework assignment we will be using art from David Bryant's comic *Aviatrix*. It's on the CD-ROM that accompanies this book. (Kristy's mom, Jana, flatted this page—see, you're never too young or too old to work in comics!)

1 Open the file Aviatrix_flat.tif from the "Homework" folder on the CD-ROM. (First, if you like, you can practice rendering this page, but for the purposes of this homework assignment we will concentrate on doing the color holds.)

2 This page has a lot of motion lines as well as rain and an explosion. Do you remember the first step to prepare this page for color holds? Yes—run the "Make Holds layer w/ Line-Art" action supplied on the CD-ROM.

3 After you run "Make Holds layer w/ Line-Art," you'll notice the document has a new layer called "Holds." Make sure it's the active layer and that you remain on it for the rest of this homework assignment.

4 Tackle the holds in each panel, one at a time, as follows.

Panel 1: Hold the lines behind Amanda Carter's head to make her stand out and to suggest motion. Choose a complimentary color, a darker color, or white, depending on your vision of the page. Keep in mind that you will need to make several color choices on this page and you may not want to use the same color for all of your holds.

Panel 2: This one poses an interesting problem. You could hold the entire panel, trace around the motion lines behind the two girls and hold those, or elect not to hold anything. Again, it depends on your vision for the page. We chose not to hold anything, as you will see in the final version (Aviatrix_holds.tif, on the facing page).

Panel 3: Hold the rain. Be careful around Amanda's face and body; be sure those lines don't become the rain color.

Panel 4: This is a big explosion. Perhaps two colors are in order here, or maybe Amanda should be affected as well.

Panels 5 and 6: These are all motion. The explosion is forcing her back. Your artistic decision is whether to hold the entire panel in one color or perhaps handle it in some other way. For example, what if you held the motion lines in one color and then held her in her correct colors (i.e., skin tone, jacket, hair, etc.)? It would take extra work, but the look might be worth it. Compare panels 5 and 6 in the Aviatrix_holds.tif file to see what I mean.

When you have finished and everything is the way you want it, be sure to run the "Finish Holds" action.

Review:
Hi-Fi Color Hold Actions

This homework assignment uses the Hi-Fi Color Hold Actions. (See page 94 for full details if you need a refresher on what these actions do and why they're so helpful.)

FROM *AVIATRIX*
Art by David Bryant
Color by Hi-Fi

Advanced Photoshop Techniques and Special Effects

Introduction by Joe Corroney, licensed illustrator for *Star Wars*, *Star Trek*, *Spike and Angel* (from the *Buffy the Vampire Slayer* series), *Dr. Who* and *The Phantom*

It's hard to imagine science fiction, fantasy or comic book heroes today without automatically thinking of the incredible imagery and illusions that enhance these stories in visual mediums. Science fiction and special effects are almost synonymous. Think of the vibrant glow of a Jedi's lightsaber, the muzzle flash and rapid-fire laser bolts from a bounty hunter's blaster rifle, or the warp-speed effect for the starship *Enterprise*. Most of the artwork I'm commissioned to create is for science fiction or fantasy properties, such as *Star Wars* and *Star Trek*, so I use a lot of special effects.

My collaborations with Hi-Fi have always exceeded my expectations, especially because of their expertise in handling the special effects necessary for my art. One of my favorite *Star Wars* illustrations that Hi-Fi colored was for a feature in *Star Wars Insider* magazine detailing the history of the Mandalorians (the culture that gave rise to Jango Fett and Boba Fett). I designed the illustration around the two main characters with other droids, ships and planets that required many atmospheric effects such as engine glows and metallic rendering for armor. Hi-Fi's work on that piece, including the fiery Mandalorian logo that dominated the background, was nothing short of amazing.

A great special effect is more than just a simple lens flare, motion blur or outer glow. It's usually a combination of these elements, plus the right level of rendering and detail. A great effect can make even the most graphical of comic book drawing styles (like mine) feel three-dimensional and alive.

In this chapter, you'll learn coloring tricks and techniques Hi-Fi has developed, and be able to utilize these for your own work.

Using Custom Swatches

Imagine that you finally land the dream job of coloring your all-time favorite hero (you know, the big guy with blue tights and a red cape). He appears in costume on just about every page of the book. So how do you keep track of his colors and make sure you use the same base tones on every page? With custom swatches.

1 Pick the Base Tone

First use the Color Picker in Photoshop to make the exact base tone you will need. In this example the color is C100/M40/Y00/K00.

2 Create a New Swatch

Next move your cursor to the first open spot in the Swatches pallete. The cursor will change into a paint bucket. Click to create a new swatch.

3 Name the Color Swatch

You will be prompted to name your color swatch. Choose a descriptive name you will easily recognize later.

4 Create More Swatches

Next time you move your cursor over your custom swatch, Photoshop will display the name you gave it. Now you can be sure you'll use the exact same shade of blue for your character on every panel of every page.

Repeat steps 1–3 for the other major colors of your character.

Pro Tip — Save Your Custom Swatches

When you've created a set of swatches, you can save it as a backup or for use on a different computer. From the menu in the Color palette, select Save Swatches, then follow the directions in the dialog box.

Make a Chart

Once you have created your swatches, you may find it useful to put them into a Photoshop document specifically for keeping track of your commonly used colors. This way you can always go back to the chart and use the Eye Dropper tool to sample colors. Hi-Fi uses this method to ensure colors are consistent from issue to issue even when multiple colorists are working on the same project. What uses can you envision for your color chart?

Start by creating a new document, making it a size that you can print easily, such as letter size. Use the Pencil tool with a square or round brush to create swatches on your canvas. Label each swatch with its name and what it's used for.

In the sample chart below, each base tone has two levels of screen tones. These swatches provide all the information a colorist needs to create a consistent look from project to project.

Character Color Charts

At Hi-Fi we juggle a lot of projects and tons of different characters. One way we maintain continuity, even with multiple artists working on a project, is with character color charts.

We start by finding a head-to-toe shot of the character in full costume. Next, the lead colorist on the project colors the character, making final decisions on base tones. The colorist then creates a color chart for each color used on the character.

Color charts will save you time. Even if you're the sole colorist on a series, having color charts will help you remember the character colors from one month to the next.

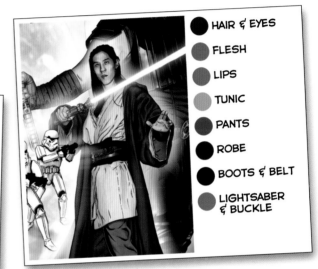

HAIR & EYES
FLESH
LIPS
TUNIC
PANTS
ROBE
BOOTS & BELT
LIGHTSABER & BUCKLE

Hi*Fi — FLATTING and RENDERING COMMON COLOR PALLET

BASE	SCREEN 1	SCREEN 2	
			Deep Blue
			Blue
			Medium Blue
			Light Blue
			Deep Purple
			Purple
			Medium Violet
			Light Violet
			Light Red-Violet
			Maroon
			RED
			Orange
			Yellow Orange
			Yellow – Light Yellow
			Golden Yellow
			Light Brown
			Medium Brown (Warm)
			Medium Brown
			Dark Brown
			Moss Green
			Pea Green
			Medium Green
			Green – Light Green
			Cool Green
			Blue Green
			GOLD
			Dark Metals (guns, swords, etc.)
			Medium Metals
			Light Metals (aluminum, light chrome, etc.)
			Smoke with common Warm & Cool screens
			Desaturated Green BG with common Warm & Cool screens
			Blue-Green BG with common Warm & Cool screens
			Purple BG with common Warm & Cool screens
			White (Teeth, Eyes, etc.)
			Flesh Tone Caucasian
			Flesh Tone Asian
			Flesh Tone African American
			Flesh Tone India-Asian

Additional Flesh Tones: So all humans do not look the same

You may have heard the term *continuity*; it means consistency. Diehard film and TV fans love to spot continuity errors that are sometimes created by cuts and scene changes—such as the character whose arms change abruptly from hanging to folded, or the sandwich with one bite taken that is almost gone a few seconds later.

Continuity applies to comics too. Anytime a character is going to appear more than once, create and use a character reference, like the one you used in this homework assignment, so that the colors of hair, eyes, costumes and other key elements stay consistent.

Brush Options in Photoshop

Photoshop's painting tools, such as the Pencil and the Brush, have many options you can configure. An entire book could be devoted to all the possible variations.

What can you do with brush options? You can use Scattering to create random textures for rocks, cave walls or tree leaves. Shape Dynamics will make your brushstrokes resemble natural mediums such as watercolor, charcoal or colored pencils. That's just a small taste of the possibilities. Experiment with different brush options and you will unlock even more creativity in yourself and your artwork.

When you are finished experimenting you can always click on Brush Presets and choose a 100-pixel soft round brush to get back to a good basic brush.

Brush with no options

(brush stroke sample)

With Scattering

Experiment With Brush Options

Create a new Photoshop document. Choose the Brush tool, then open the Brush palette. Click the check box next to Shape Dynamics to activate it, then click its name to see the options. Drag your brush around the canvas and try out the various options. When you are done test-driving Shape Dynamics, uncheck it and move on to Scattering. Repeat until you have experimented with all the brush options. Then start having fun by checking multiple options.

With Scattering, Shape Dynamics and Color Dynamics

The Magic of Brush Options

Here's a Photoshop brush that resembles a blade of grass. With no options enabled, the results are unspectacular (above, top). Just by enabling a few options, you can fill an area with seemingly random blades of grass in no time.

Pro Tip — The "Spacing" Brush Option

Spacing, one of the Brush Tip Shape options, changes how often the brush shape repeats. A low number such as 10 or 15 will cause the brushstroke to look smooth and fluid. A larger number such as 75 or higher will create gaps in the stroke.

Spacing significantly affects all the other brush options. For example, when you enable Scattering, you also may want to increase the spacing to achieve more gaps. With a little bit of experimentation and practice you will have your brush doing things you never imagined possible.

Custom Brushes

Did you know you can also make your own brushes in Photoshop? You can make a brush from any grayscale image. You can even make a brush by drawing a smiley face, or maybe a brush of your signature. The possibilities are endless.

1 Choose an Image
Open your photo, doodle or other artwork in Photoshop.

2 Convert to Grayscale
Choose Image menu > Mode and convert the file to grayscale.

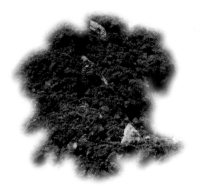

3 Make a Selection
Use any selection tool to select the part of the image you want to turn into a custom brush. If you want to define a brush with soft edges, select pixels with gray values. (Colored brush shapes appear as gray values.) Feather should be set to 0 pixels if you want to create a brush with a sharp edge. The brush shape can be up to 2500 pixels × 2500 pixels in size.

4 Define the Preset
Choose Edit > Define Brush Preset. Name your custom brush, then click OK. Choose your new brush from Brush Presets in the Brushes palette, then try it out.

Creating a Simple Photoshop Action

We're always looking for ways to automate repetitive tasks so artists can spend more of their time being creative. One of the most powerful tools Photoshop offers in this area is the ability to create *actions*.

What are actions, and what can they do? Simply put, actions let you record certain Photoshop commands and processes step by step.

Example: Create an Action to Re-Save Files as 72ppi RGB JPGs

Let's say you're hard at work on a comic book, and you need to send your editor an overview of the work you've done so far.

Of course, the files you're creating for the comic book are high-res CMYK TIFFs, so they're big files. Uploading them to an FTP server would be time-consuming. It would be faster for you (and more considerate to your editor) to send low-res RGB JPGs instead.

You could convert each page of your comic from CMYK TIFF to RGB JPG one at a time . . . or, you can quickly build an Action and let Photoshop batch process the files for you.

1 Create a New Actions Set and a New Action

Open any hi-res CMYK file. From the Actions palette, create a new actions set named Comic Book Actions and a new action named 72ppi JPG.

2 Start Recording, Then Change the Image Mode

Press the red round button at the bottom of the Actions palette to start recording. Choose Image > Mode > RGB.

3 Change the Image Size, Save and Stop Recording

From the menu-bar choose Image > Image Size and enter 72 as the value for Resolution. Choose File menu > Save As and save the file someplace else. (If you are using the file organization system from page 15, you can save this in your JPGs folder.) Press the square Stop button at the bottom left of the Actions palette. Close the file. If you do not actually need this JPG, go ahead and delete it from your hard drive now.

You have now recorded an action that will convert hi-res CMYK files into low-res RGB JPG files. Next, we'll show you how to use this action to batch process files.

Batch

Play

Set: Comic Book Actions

This is the action → Action: 72ppi JPG
you want Photoshop
to perform.

OK

Cancel

Source: Folder

The batch of images → Choose... Macintosh HD:Users:...:Superman:CMYK TIFFs:
you want to process
are in this folder.
☐ Override Action "Open" Commands
☐ Include All Subfolders
☐ Suppress File Open Options Dialogs
☐ Suppress Color Profile Warnings

Destination: Folder

This folder is where → Choose... Macintosh HD:Users:...:DC Comics:Superman:JPGs:
the new images will
be saved.
☑ Override Action "Save As" Commands

File Naming

Example: MyFile.gif

Document Name ⬦ + extension ⬦ +

⬦ + ⬦ +

⬦ + ⬦

Starting serial#: 1

Compatibility: ☐ Windows ☑ Mac OS ☐ Unix

Errors: Log Errors To File ⬦

Save As... Macintosh HD:...:Adobe Photoshop CS2:ikea.txt

4 Prepare Files and Folders for the Batch Process

Set up two folders on your hard drive (you can give
them any name that makes sense to you):

- A *source folder*. This folder should contain all the image files
 you want to process. Every file in the source folder will be
 processed, so make sure there's nothing extraneous in it.
- A *destination folder*. Create a new, empty folder to receive
 the low-res JPGs that the batch process will generate. This
 folder can be anywhere except within the source folder.

5 Configure and Run Your Batch

Choose File menu > Automate > Batch. When the Batch
dialog box opens, select the Set and Action you want to use
if they aren't already selected. Configure the batch as follows,
click OK, then get a coffee, stretch your legs, or check your
email while Photoshop batches your images for you.

- *Source:* Set to "Folder," then click the Choose button and
 choose the folder where your hi-res CMYK files reside.
- *Destination:* Set to "Folder," then click the Choose button
 and choose the folder where you want the low-res RGB
 JPGs to end up.
- *Override Action "Save As" Commands:* Check this box to
 ensure the JPGs end up in the folder of your choosing.
 If you fail to enable this option, your JPGs may not be
 created or may end up in some dark recess of your hard
 drive. Most likely Photoshop will look as if it is batching
 your files, yet your destination folder will remain empty.

 Pro Tip Get to Know Photoshop Actions

The action you've created in this lesson is just the tip of the
iceberg. Photoshop's actions and batch processing are powerful
tools. At Hi-Fi we use actions to batch images daily to save time
and ensure consistency. You can learn more about actions and
batch processing from the Photoshop help section. Choose Help
menu > How to customize and automate > To automate tasks.

Creating and Using Hi-Fi Helpers

In chapter three you were introduced to the concept of reusable artistic elements we call Hi-Fi Helpers. These are files you create once and use over and over again. We use them often to build up skies, landscape patterns and other areas quickly. We're going to show you how to make your own Hi-Fi Helpers, so that you can save time and enjoy greater continuity from page to page and from project to project.

Pro Tip — Best Size for Hi-Fi Helpers

When you create your own Hi-Fi Helpers, a good general size is 10" × 4" (25cm × 10cm) at 300ppi. Those proportions are well suited to landscape elements such as skies, water or earth, and the size is large enough that you can scale the image without noticeable loss of quality.

1 Paint a Sky

Create a new document 10" × 4" (25cm × 10cm) at 300ppi. Pick a pale blue and use the Gradient tool to screen some light up from the bottom of the image. This helps give the illusion of a horizon.

Experiment with brush sizes, using a white or pale blue screen tone to paint clouds. Your clouds could be big and fluffy, dark and stormy, or light and wispy. Use your creativity.

Hi-five

If you have not attempted to paint a sky before you might find this challenging. Don't worry about making a perfect sky on your first attempt; just have fun. You can always paint more clouds later.

2 Create Sand and Rocks

Create another new document in Photoshop, again 10" × 4" (25cm × 10cm) at 300ppi. Using the advanced brush techniques you learned earlier in this chapter (page 106), create the look of scattered sand and rocks similar to our example.

Create a folder on your hard drive named "Hi-Fi Helpers" and save these images as Blue Sky 01.tif and Sand & Rock 01.tif. Keep both documents open in Photoshop.

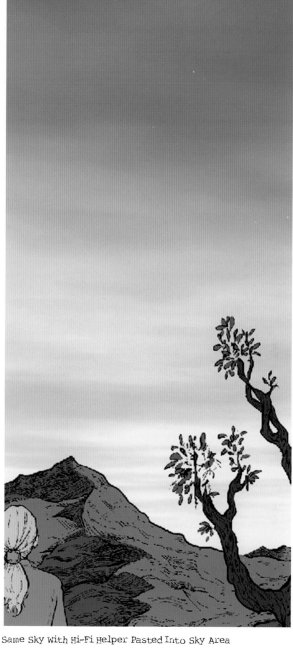

Sky With Gradient Only

Same Sky With Hi-Fi Helper Pasted Into Sky Area

3 **Add a Gradient to the Sky**
Open the file SiP_89_cvr_400.psd in chapter five of the "Lessons" folder on the CD-ROM. With the Magic Wand, select the entire sky area. Lighten the sky from bottom to top using the Gradient tool set to Screen mode.

4 **Select the Sky, Then Paste In the Hi-Fi Helper**
Next make Blue Sky 01.tif your active document. Choose Select > Select All then Edit > Copy from the menu bar. Make your comic page your active document and choose Edit > Paste Into. The Blue Sky image should now appear inside of the sky. Set the sky layer to Multiply mode. Use the Free Transform tool to scale the Blue Sky image until it completely fills the sky area. Play with the positioning of the sky until you are happy with the results.

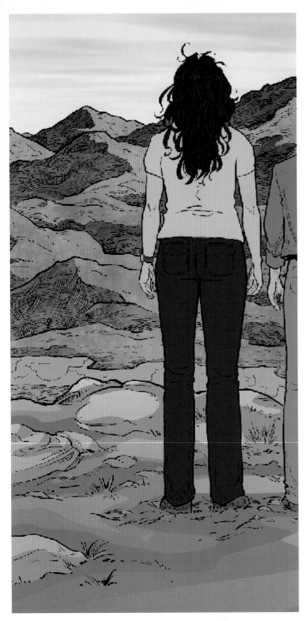

Ground and Mountains With Cut and Grad Only

Ground and Mountains With Hi-Fi Helper Overlay

5 Select Cuts on the Ground and Mountains

For the ground and mountains use the Hi-Fi four-step process and cut and grad techniques from chapter three to create some basic cuts on the surfaces. Once you have a few basic cuts completed make sure all of the ground and mountain areas are selected. (HINT: You may need to use the Flats channel.)

6 Paste the Hi-Fi Helper Into the Selection

Next make Sand & Rock 01.tif your active document. Choose Select > Select All, then Edit > Copy from the menu bar. Make your comic page your active document and choose Edit > Paste Into. The Sand & Rock image should now appear inside of the ground and mountains. Set the Sand & Rock layer to Overlay mode and adjust the transparency to 50%–65%. Use the Free Transform tool to scale the Sand & Rock image until it completely fills the ground and mountains area.

Quick Effort
Wow, look how good your image looks after only a short amount of time! You have the basic sky and ground rendered and you are ready to move on to the main characters.

What You Can Accomplish With More Time
By investing a bit more time in creating detailed and varied helpers, you can achieve results like these! (Images on pages 112–113 are from the final printed cover of Terry Moore's *Strangers in Paradise* vol. 3 #89.)

Hi-Five

Now you know how to create and use a basic Hi-Fi Helper. You can take your ideas much, much further— paint a more elaborate sky, create water images for ocean scenes, or even make patterns of leaves to use on trees. You can look to real-life and photographs for inspiration when creating your own helpers. The only limit to what you can accomplish using this technique is your own imagination. Go forth and create!

The Hi-Fi Method for Creating Special Effects

Have you ever wondered how to create fire, gun blasts and sparkles that glow with the look of real light? What if there was a way to use the "painting with light" techniques you have learned in this book to add magical glows, brilliant lighting and amazing special effects to your art?

Up to this point you have used Screen mode with your Brush and Gradient tools, but you may not know that Photoshop allows you to set entire layers to Screen mode as well. This means you can create special effects on their own layer, which has several benefits:

- It leaves all the rendering you have done on your Background layer untouched and editable.
- You can make changes to your special effects at any time without having to redo any work to the layers below.
- You can store your special effects as Hi-Fi Helpers that you can use over and over again to save you time and increase consistency from project to project.

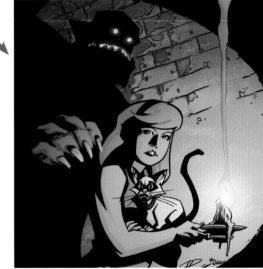

Screen Mode for Layers

At Hi-Fi we like to put special effects on a separate layer that is set to Screen mode. When a Photoshop layer is in Screen mode, 100% black becomes transparent. When you use a brush that is in Screen mode to paint on a layer that is in Screen mode, the light is passed down to all underlying layers, creating a realistic, luminous look without altering any of the line art or rendered color underneath.

 Pro Tip How to "Erase" in Screen Mode

Here is a tip to keep you out of trouble. To erase or tone down an area in Screen mode, paint with 100% black using the Brush tool set to Normal mode. Never use the Eraser tool on a layer that is in Screen mode.

Using the Hi-fi Step 2 Script

Remember those three Hi-Fi Scripts you installed way back at the beginning of the book? You used the first one, Hi-Fi Step 1, on page 30. Now it's time to use Hi-Fi Step 2, which sets up your page for special effects.

In each example in this chapter, after you run the Step 2 script you will use the Brush or Gradient tool set to Screen mode to paint with light on your Special Effects layer. If you are unsure of your tool settings, check page 62.

The Hi-Fi Step 2 Script

The Hi-Fi Step 2 script creates a temporary Line-Art layer over your background and color holds. It also creates a Special Effects layer in Screen mode, allowing you to paint with dazzling glows, sparkles and other light effects. Important tips:

- If you want to do any color holds on your page, you need to do so before you run the Step 2 script. (See chapter four for details on color holds.) Remember, the order in which to complete comic book pages is flats, rendering, color holds, special effects and color separations.
- Before you run the Hi-Fi Step 2 script, be sure your Layers palette matches one of these two "before" examples shown here; otherwise you may experience unexpected results.

Before running Hi-Fi Step 2, your Layers palette should look like one of these examples:

After running Hi-Fi Step 2, your Layers palette will look like this:

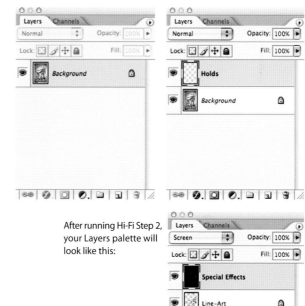

Review:

Accessing the Hi-Fi Scripts

In each lesson in this chapter, you will be instructed to run the Hi-Fi Step 2 script before starting. Remember, you access the scripts from the File menu in Photoshop. To run the Step 2 script, choose File menu > Scripts > Hi-Fi Step 2.

Extra Credit

When you've created each of the special effects in this chapter, save them and use them anytime you like. To use an effect, copy and paste it into any Photoshop document that is in RGB mode. Then set the layer with the effect to Screen mode so that the effect appears to float over the base image. You can move and scale the effect, or you can even use Image menu > Adjustments > Hue/Saturation to change its color.

Add a Glow

The basic special effect everyone should learn is a simple glow. A glow can represent the flame of a candle, the reflection of light off shiny armor, the pulsating light of a computer monitor, or the fiery eyes of a monster. Glows are easy when you do them the Hi-Fi way.

Review:

All the special effects demos in this chapter assume that you have installed the Hi-Fi Step 2 script. If you haven't done this yet, see page 115.

1 Run the Hi-Fi Step 2 Script
When you are ready to add special effects to an image, first run the Hi-Fi Step 2 script. After that, make sure the layer named Special Effects is the active layer (the active layer is the one highlighted in blue).

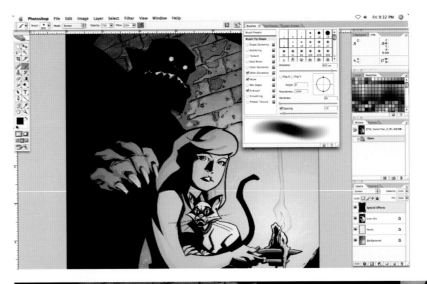

2 Create a Glow Using the Brush in Screen Mode
Be sure your Brush tool is set to Screen mode. Choose a color for your first glow. In our example, the monster's eye glow red, his mouth glows orange, and Tommi's candle glows yellow-orange with a white-hot center.

Before you start brushing, imagine how a candle's flame would glow. The flame would project light from the center outward in a spherical sort of way. Starting with a 100-pixel brush size, touch the Brush tool to the center of the area you want to glow and use a swirling motion to work your brush out from the center. This will keep the brightest part of the glow in the center. Make one or two more passes with the Brush tool, each time using a larger brush size to soften the look of the glow.

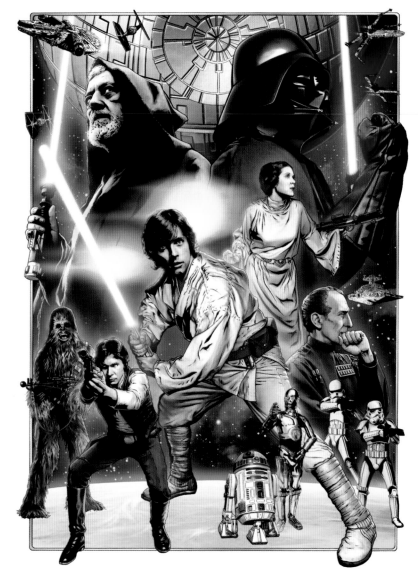

Creative Ammo
Lightsabers get the glow treatment in this illustration by Joe Corroney, done for a limited-edition print in honor of *Star Wars* Celebration IV.

Courtesy of Lucasfilm Ltd.
Art by Joe Corroney
Color by Brian Miller

White-Hot Effects
Lightning painted onto a Special Effects layer.

DIGITAL WEBBING PRESENTS #34 THE ENIGMAS
Story by Dustin Yee
Art and color by Brian Miller

Give It Flare

If you read comics you've probably seen the generic built-in Photoshop lens flare a million times. So has everyone else! Be original and make your own flare that has your distinct creative stamp all over it. It takes just a few minutes.

Review:
All the special effects demos in this chapter assume that you have installed the Hi-Fi Step 2 script. If you haven't done this yet, see page 115.

1 Start the Flare on a Black Background

Create a new Photoshop document in RGB mode, 8" × 8" (20cm × 20cm) at 300ppi. Reset your colors to black and white; you can do that quickly just by pressing the D key on your keyboard. Fill the entire background with solid black by using the Option-Delete keyboard shortcut (PC: Alt-Delete).

Choose a color for your flare. It could be bright blue, yellow, green, whatever you like, but a bright color with medium to rich saturation works best. Then use the Brush tool in Screen mode with the Brush presets from page 62 to create a soft spot in the center of the canvas. Start by touching your brush to the central spot and working outward in an overlapping spiral movement to enlarge the glowing spot.

D key
Pressing the D key resets the foreground and background colors to black and white. (Think "D" for "default".)

2 Brush In the Rays

Select the Lasso tool and set it to have a feathered edge (choose a feather value in the range of 8 to 16 pixels). Now lasso the area that will contain the rays of the flare. For best results, lasso out from the center, making each ray wider as it nears the edge of the canvas. You can use Option-Lasso (PC: Alt-Lasso) to create straight lines with the Lasso; just click from one point to the next.

Now use the Brush tool and the color from step 1 to stroke repeatedly from the center of the flare outward. You may need to change the brush size to get the right effect. Start with a brush approximately one-half the diameter of your flare's center. In chapter three, we often dragged a brush down the center of a cut, but that won't work here. Instead, touch the brush down in the center of the flare, then work outward in a gentle overlapping spiral motion around the entire flare to spread the light out evenly from the center. This way, all the rays will look the same.

To keep your rays from having an abrupt edge, do not let your strokes go all the way to the edge of the canvas.

When done, choose Select menu > Deselect to drop the selection.

3 Make Smaller Cuts, Then Brush Again

For more detail and depth in your flare, repeat step 2, except lasso new rays that lie entirely inside the area you selected the first time. Remember, in Screen mode you are painting with light; every stroke makes the area lighter and brighter. So you do not need to change your screen tone for this step.

4 Add a Glow to the Center

Stroke the Brush tool several times around the center until the area looks white-hot.

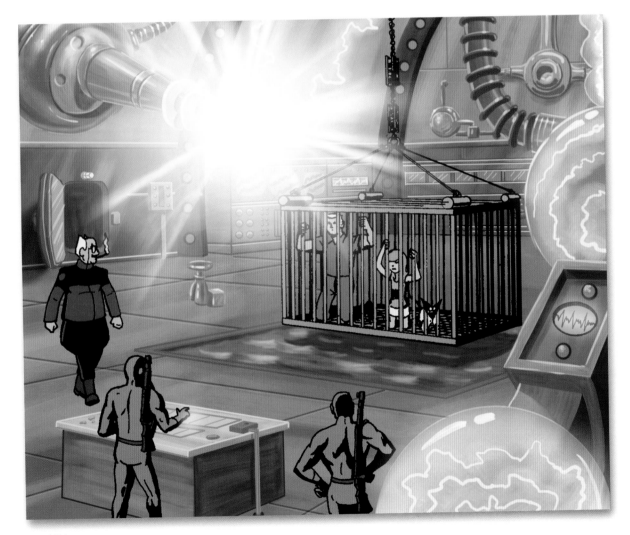

A Brilliant Trap
Here the flare is represented by energy powering out of the weapon.

IMAGE FROM *THE TERRIFYING TALES OF TOMMI TREK* #2
Published by Funk-O-Tron
Art by Mike Worley
Color by Hi-Fi

Make It Sparkle

A sparkle is different from a flare. A sparkle is petite, simple—dare we say elegant? Use sparkles to accent jewelry, add a dash of life to a crooked smile, or suggest a razor-sharp edge on broken glass.

Review: All the special effects demos in this chapter assume that you have installed the Hi-Fi Step 2 script. If you haven't done this yet, see page 115.

1 Make a Soft Center on a Black Background

Create a new Photoshop document in RGB mode, 8" × 8" (20cm × 20cm) at 300ppi. Reset your colors to black and white by pressing the D key on your keyboard. Then fill the entire background with solid black by using the Option-Delete keyboard shortcut (PC: Alt-Delete).

Choose a bright, saturated color for your sparkle and use a 100-pixel soft round brush in Screen mode with the Brush presets from page 62 to create a soft spot in the center of your canvas. Use several tight circular strokes to build up a slight highlight in the center.

2 Select and Brush the Rays

Select the Lasso tool and set its feather value to 0 pixels. Lasso the X-shaped sparkle area in one movement, using the Option-Lasso technique (PC: Alt-Lasso) from the previous lesson to create straight lines. Lasso out from the center, making each ray come to a point.

Use the Brush tool in Screen mode to stroke in an overlapping spiral from the center of flare outward. You may need to adjust the brush size up or down; use the left and right bracket keys to do that, and experiment until you achieve the right effect. As in the previous lesson on creating flares, don't try to paint the individual rays of the sparkle with your brush, or it won't look like real light emanating evenly from the center of the sparkle. To ensure that the rays fade gently at their tips, do not let your strokes go all the way to the edge of the canvas.

When done, choose Select menu > Deselect to drop the selection.

3 Add a Glow to the Center

Use the Brush tool again to add a glow over the center of your sparkle. Circle the center several times until it looks white-hot.

Multiplying Sparkles
You can create one sparkle and repeat it many times on an image, adjusting its size and color to create exciting images such as this *New X-Men* cover.

COVER IMAGE, *NEW X-MEN* #120
X-Men™ © 2002, Marvel Characters, Inc.
Used with permission.
Art by Frank Quitely
Color by Hi-Fi

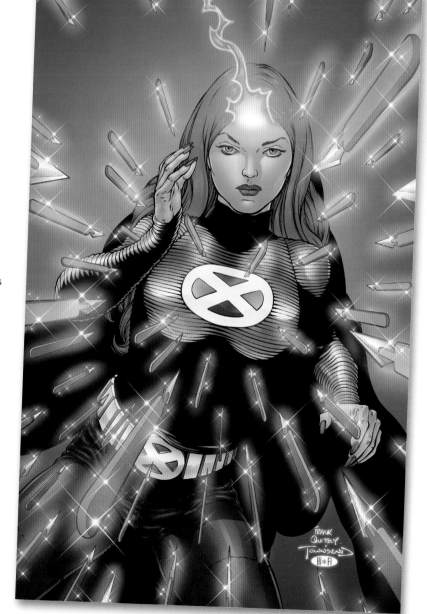

Ka-Blam!

A blast of gunfire or energy is like a glow with the added concept of motion.

Review:

All the special effects demos in this chapter assume that you have installed the Hi-Fi Step 2 script. If you haven't done this yet, see page 115.

1 Brush the Basic Shape of the Blast

Create a new Photoshop document in RGB mode, 8" × 8" (20cm × 20cm) at 300ppi. Reset your colors to black and white by pressing the D key. Fill the background with black by pressing Option-Delete on your keyboard (PC: Alt-Delete).

Choose a bright, saturated color. Using a 100-pixel soft round brush in Screen mode with the Brush presets from page 62, create the large circular end of the blast—this is the muzzle flash. Now use the Lasso tool with a generous feather (30 to 40 pixels) to select a cone shape extending off the flash. Brush color into the selection to finish the blast shape.

2 Select and Lighten Inside the Blast

Use the Lasso tool (with the same feathering value as in step 1) to create a cone-shaped selection entirely within the area you painted in step 1. Brush several times to build up a hot-zone inside the blast.

3 Add Details Using the "Scatter" Brush Option

In the Brush palette, enable the Scatter option, then use the brush to create the look of particles discharging from the blast point. Stroke the brush from the center of the flash outward, allowing the color to fade away. Try dragging your brush in small swirls to get the splatter to give you more irregular-looking particles.

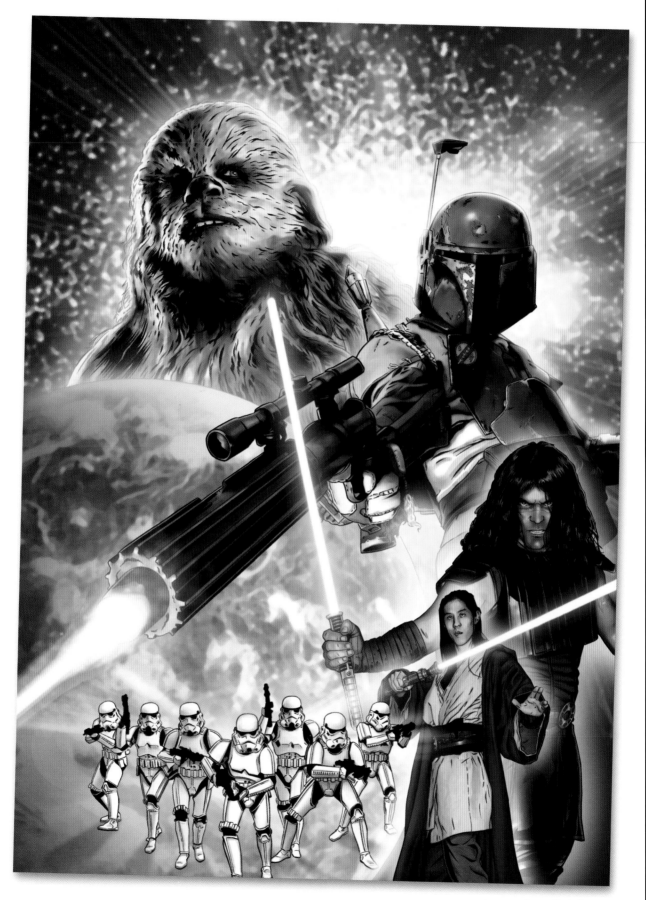

Quick Draw: Locked and Loaded
Boba Fett blasts unseen enemies on Joe Corroney's cover
illustration for the Motor City Comic Con program.

Courtesy of Lucasfilm Ltd.
Art by Joe Corroney
Color by Brian Miller

Flame On

Fire can be a challenge for even the most talented pencillers, inkers and colorists. Use this technique to give your fire an extra spark that will bring your page to life.

Review:
All the special effects demos in this chapter assume that you have installed the Hi-Fi Step 2 script. If you haven't done this yet, see page 115.

1 Create the Basic Flames

Create a new Photoshop document in RGB mode, 8" × 8" (20cm × 20cm) at 300ppi. Reset your colors to black and white by pressing the D key. Fill the background with solid black using Option-Delete (PC: Alt-Delete).

Choose a deep, saturated orange. Using a 100-pixel soft round brush in Screen mode with the Brush presets from page 62, create flowing brushstrokes, building up a band of highlighting across the center of the flames.

2 Brush With the Scatter Option

Select the Scatter option in the Brush palette. Randomly stroke the brush within the flames near the edges to create the look of particles. As you add brushstrokes, the flames will become lighter. Keep the lightest highlight at the bottom center of the fire.

3 Add Some Wave

To make the flames appear to be "licking," distort the image by choosing Filter menu > Distort > Wave. A good starting point for the settings would be as follows, but definitely experiment with your own unique filters.

- Generators: 3
- Type: Sine
- Wavelength: min. 75; max. 150
- Amplitude: min. 10; max. 50
- Scale: 100% horizontal and vertical
- Repeat edge pixels

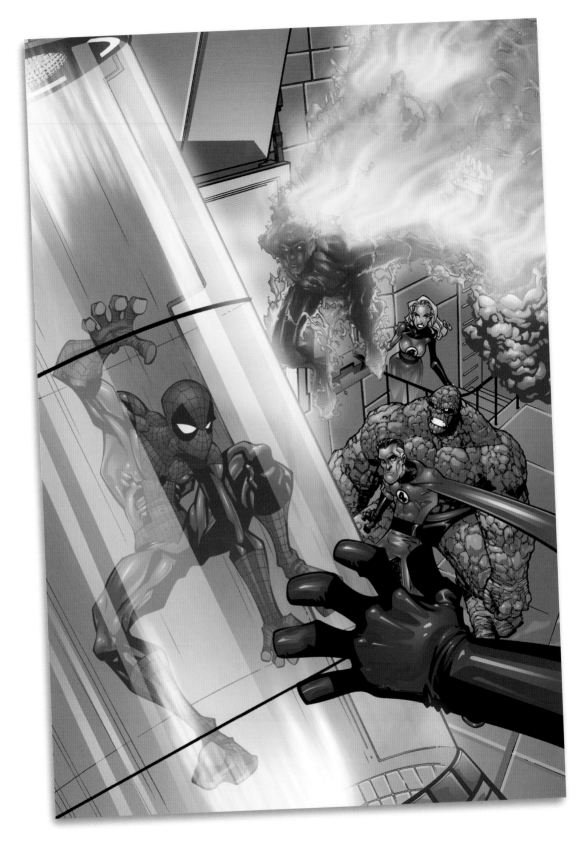

The Human Torch Blazes Into Action.
The Fantastic Four think they've trapped a villain. They
don't suspect the costumed character's real powers in their
first encounter with the Amazing Spider-Man.

Use a Force Field

Protect your hero while traveling in space or surround your foe with constrictive energy. Either way you'll need a powerful force field to save the day. In this lesson you will learn how to create a force field effect.

Review: All the special effects demos in this chapter assume that you have installed the Hi-Fi Step 2 script. If you haven't done this yet, see page 115.

1 Make a Sphere

Create a new Photoshop document in RGB mode, 8" × 8" (20cm × 20cm) at 300ppi. Reset your colors to black and white by pressing the D key. Fill the background with solid black using Option-Delete (PC: Alt-Delete).

Use the Elliptical Marquee tool to select a circle with a slightly feathered edge (6–8 pixels). Then choose a soft round brush set to Screen mode, with the presets from page 62, about one-half the size of your selection.

Gently add color to the edges of the circle as shown, using a warmer color for the upper highlight and a cooler color for the lower highlight. This will give your force field a more three-dimensional look, enabling the reader to believe that someone or something could be inside it. You do not have to make your force field look exactly like ours. Be creative and pick wild colors—use your imagination.

2 Add Some Brush Texture

Use Brush Texture (an option in the Brushes palette) to add some sizzle and crackle to your sphere. Experiment and have fun with this options. The goal is to give the illusion of static energy or particles dancing across the surface of the bubble.

KEYBOARD SHORT CUT

Option-Shift with Elliptical Marquee (PC: Alt-Shift)

Allows you to drag from the center to create a perfectly circular selection.

3 Do a Glow

Paint a soft halo glow around the perimeter of the sphere. This will create the impression of pulsating energy.

Review:

Creating Glows

See pages 116–117 to review the steps for creating a glow.

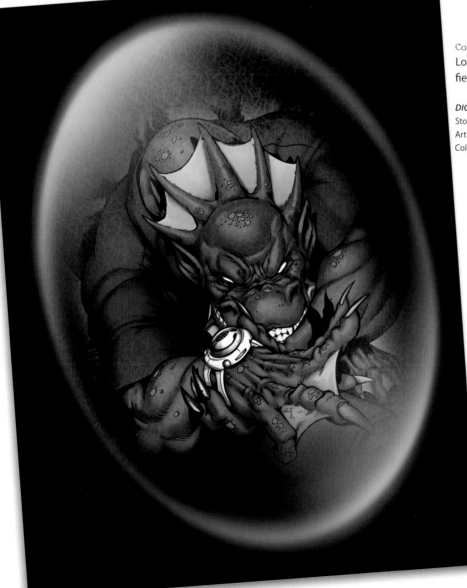

Constrictive Energy

Loch Mo is captured by an enemy force field in this image from *The Enigmas*.

DIGITAL WEBBING PRESENTS #34 *THE ENIGMAS*
Story by Dustin Yee
Art by Casey Maloney
Color by Hi-Fi

Creating Warp Effects

ast off for the final frontier, travel through time or break the
und barrier. Here's a quick and easy way to create a warp effect.

Review:

All the special effects demos in this chapter assume that you have installed the Hi-Fi Step 2 script. If you haven't done this yet, see page 115.

1 Use the Render Clouds Filter

Create a new document as in the previous special effects lessons. Select a high-contrast pair of foreground and background colors, then fill the document using Filter menu > Render > Clouds.

2 Make It Grainy

Add random contrast to the image with Filter menu > Texture > Grain. Set the specifications as follows: Intensity, 75; Contrast, 50; Grain Type, Clumped.

3 Do a Blur

Create the warp effect with Filter menu > Blur > Radial Blur, setting the Zoom to 100.

4 Add Color

Use the Angle Gradient tool on your warp. We used a rainbow color setting with 50% opacity and with the mode set to Color.

5 Paste In a Flare

Create an "event horizon" in the center of the warp by pasting in the flare you created on pages 118–119. Set the flare layer to Screen mode, position your flare in the center of the warp and flatten the image.

Extra Credit

Use your warp as a background, or paste it into other documents. With the warp floating on a layer over other images, you can try different layer modes such as Screen, Overlay and Color to achieve brilliant effects. Cycle through all the layer modes for fun and see what they do. You never know what cool effect you'll come up with on your own.

Beam Your Page to Life
With the five simple steps you just learned,
you can make a warp effect similar to this one.

COVER IMAGE FROM *STAR TREK: THE NEXT GENERATION: THE SPACE BETWEEN* #6
Published by IDW Publishing
Art by Joe Corroney
Color by Hi-Fi

Assignment 1:

Swatches and Brushes

For this homework assignment you can use a piece of your own art or a piece supplied on the CD-ROM.

Make a Character Color Chart

Choose a comic book character. It could be one you have created or a favorite published character. Make a palette chart for the character. Don't forget the small yet important areas of color, such as eye, skin and clothing details. Give each base tone a name you will remember, so that you know who's who and what's what.

Brushes

Get your signature into the computer, either with a graphics tablet or by signing a piece of white paper with a black marker and scanning it in bitmap mode at 600dpi. Turn this signature into a brush (see page 107). Now you can add your signature to artwork easily whenever you need it, and it will be the same every time.

Now get creative. Take another piece of white paper and put something on it: perhaps a coffee stain, a thumbprint or a splatter of actual paint. Scan it in and turn it into a brush. Try another. And another.

Review:

Custom Swatches and Character Color Charts

If you need to review custom swatches, flip back to page 104.

For a refresher on character color charts, see page 105.

Messy, but Cool
This brush was created by dragging lipstick on a napkin, then scanning it.

Assignment 2:

Special Effects

Did you know that the special effects you learned to create in this chapter are used in other industries besides comics?

Pimp This Ride!

For this homework assignment you will need to open two files from the chapter five "Homework" folder on the CD-ROM: Bike_01.tif and Bike_02.tif.

Make a lens flare in Photoshop, or open the one you already made. Add sparkles of varying sizes and colors to the chrome and the paint. Go crazy—really make them pop!

What other effects that you've learned in this chapter can you apply to these motorcycles?

Extra Credit

Pick up a copy of your favorite magazine, preferably one with a lot of advertisements in it. Look though the ads and even the pictures that accompany the stories. How many special effects techniques can you find?

There is an entire industry devoted to retouching photos to make them sparkle, glow, fade, and so on. Special effects aren't just for comic books anymore.

Bike_01.tif

Bike_02.tif

Super-Power Pro Tip — Multiple Screen Layers in One Document

You can have multiple screen layers in a document, then merge them together. As an example, you might be doing some special effects on a page and decide you want to add a sparkle you created earlier. Open your Sparkle file, then use the Move tool (the black arrow) to drag and drop the sparkle from its own window right into the document you are currently coloring. Photoshop will automatically put it on a new layer. Use the Move tool to position the sparkle where you want it, then use Edit menu > Free Transform to scale and rotate as needed. Finally, use Merge Down (Command-E [PC: Ctrl-E]) to merge the sparkle into the Special Effects layer.

Use this tip to leverage the power of your Hi-Fi Helpers to give your pages that extra shine without creating extra work for yourself.

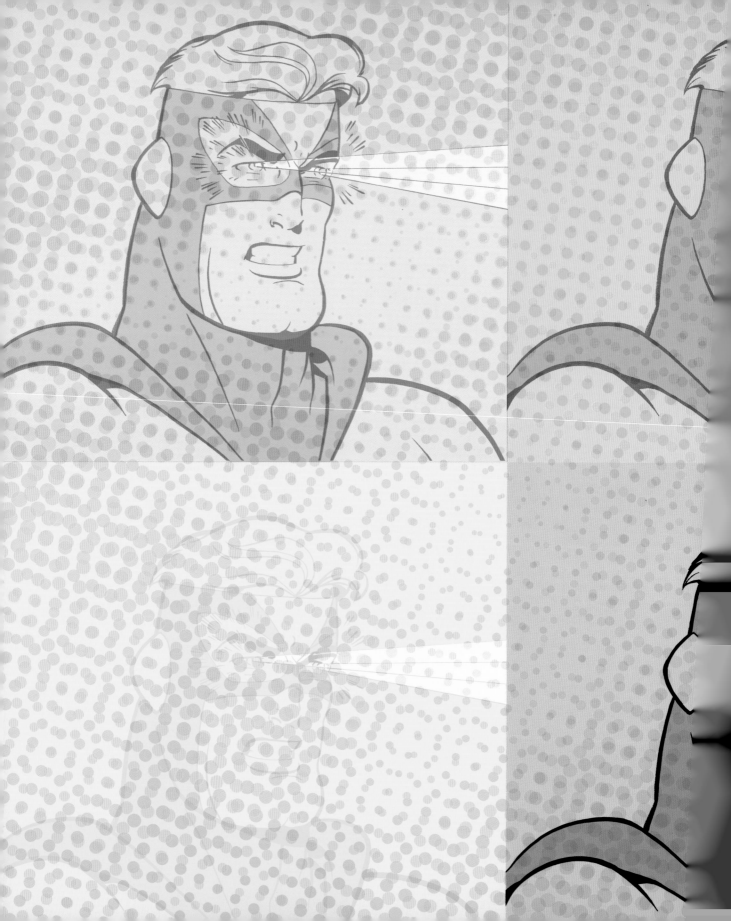

Demystifying Digital Art and Color Separations

Introduction by Gail Simone, writer for DC Comics' *Birds of Prey*, *Wonder Woman* and *Secret Six*

In this chapter you'll learn about digital art and the difference between bad color separations and good ones. First, let's get the truth-in-advertising out of the way: I don't know much about comic coloring, and I know even less about color separation and trapping. To me, that sounds vaguely insidious, like an activity that radicals commit in darkened alleyways over steaming mugs of Russian coffee. Possibly wizards are involved.

I used to be a hairdresser, with special certifications in color correction, and I knew how important color can be. But because I was thrown into the deep end of the comics-writing pool somewhat unceremoniously, I somehow missed whatever starter course most writers get about coloring. My color notes in my scripts usually ran roughly about this deep: "This guy's shirt is green. Or purple. Whatever."

But something happened when I got the *Birds of Prey* assignment and started getting back colored scans from Hi-Fi. Suddenly, scenes were more intense, more emotional. The occasional muddiness I got from some other colorists was gone. The character moments had a zest that even the original black-and-white art didn't fully capture. In short, it finally got into my thick skull that a colorist does more than make a book pretty—they tell a story, every bit as much as the writer and artist.

At least, the great ones do.

If you're an aspiring color artist, I hope you'll learn all you can about the technical stuff behind the specs, and that you'll take the examples of good and not-so-good color separations in this chapter to heart. Make us all proud.

SUPER-COLOR-VISION
Art by Mike Worley
Color by Brian Miller

Resolution

Want to make the right choices when coloring your artwork, and avoid all sorts of problems? Then take some time with us to learn about resolution and how monitors, printers and presses reproduce images.

How Art Is Reproduced

Images containing gradations of color and tone, such as photographs and today's digitally-colored comics, are referred to as "continuous tone" images. To create the appearance of a continuous-tone image on a printing press or a computer monitor, we must break it up into a grid of tiny, individually controllable spots of either ink or light. These spots are tiny enough that the eye can't perceive (or can easily overlook) the spaces between them, so the resulting image looks smooth. That grid of spots is called a *screen* (not to be confused with a computer screen, which we'll always refer to as a monitor). The fineness or density of the grid is called its *resolution*.

DPI and PPI

Since an image is reproduced with dots, its resolution is measured by counting how many dots are squeezed into a given linear measurement.

On a computer monitor or a digital camera's image sensor, that smallest controllable spot is called a *pixel*. So the resolution of digital images and computer monitors is measured in *pixels per inch (PPI)*. Most computer screens are in the range of 72 to 96ppi; some exceed 100ppi.

On most desktop output devices, including inkjet printers and laser printers, the smallest controllable spot is called a *dot*, so resolution is measured in *dots per inch (DPI)*.

Close-Ups

Pixels on a Monitor (Grayscale Mode)
Pixels in a digital photo that have been converted to Grayscale mode. Each pixel can be a different shade of gray.

Screen Dots on a Printed Black-and-White Page
This is how the black-and-white image looks when printed. The image is screened, or converted into a grid of dots. Each screen dot is black; the illusion of shades of gray is created by varying the sizes of the dots.

Pixels on a Monitor (RGB Mode)
Pixels in the same digital photo in RGB color mode. Each pixel can be a different color.

Screen Dots on a Printed Color Page
This is how a color image looks when printed. When you convert an RGB image into CMYK mode, the software creates channels of cyan, magenta, yellow and black. At the printer, each of those channels is screened (converted into a grid of dots) separately, then the press prints the grids one after another.

Most of today's laser printers are 300–600dpi.

Imagesetters and platesetters (the computerized systems that create the printing plates for books and magazines) also use dots. These devices are at least 1200dpi.

LPI

Still with us? Keep going—this knowledge will set you apart from the crowd if you are serious about a coloring career.

LPI (lines per inch) is the item most people don't understand and do not take into account when preparing work for print in comics and magazines.

As you saw in the close-ups on the previous page, printed images are made up of one or more grids of ink dots. The fineness of the grid is measured by how many lines of dots fit into an inch, or lines per inch. LPI is also called *line screen* or *line frequency*.

LPI describes the fineness of the screen of dots the output device creates. Remember, LPI is an attribute of output devices, not of digital files. Commit that important fact to memory before you turn the page.

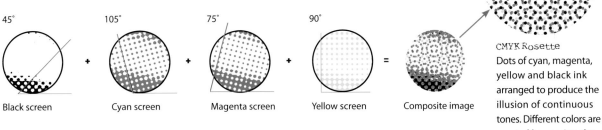

Black screen + Cyan screen + Magenta screen + Yellow screen = Composite image

CMYK Rosette
Dots of cyan, magenta, yellow and black ink arranged to produce the illusion of continuous tones. Different colors are created by varying the sizes of the dots.

CMYK Printing in More Detail
Printing presses for most books and magazines use four ink colors: cyan, magenta, yellow and black. This is called CMYK or four-color process printing.

CMYK Dots
Using a printer's loupe or magnifying glass, you can see the CMYK dots on a printed page.

Why Do We Use 72ppi for Art Viewed on Screen?

Traditionally, printers have used *points* as their unit of measurement. A point is $\frac{1}{72}$ of an inch. The first Apple Macintosh monitors were made 72ppi so that a 10-point font would display at its true size. It was called WYSIWYG ("what you see is what you get"), and we take that capability for granted now, but at the time it was a major innovation.

The standard for scanning images for screen display has become 72ppi even though many monitors today are not 72ppi. But 72ppi still works as a decent ballpark figure, since most monitors range from 72–96ppi.

The **Difference** Between **DPI** and **LPI**

How LPI and DPI Relate

On a computer screen, one pixel in the digital image should equal one pixel on the screen (ideally).

But as you learned on the previous page, LPI is a descriptor of output devices only. Next important fact: *One pixel in a digital image does not equal one screen dot on a printed page.* In fact, it takes many pixels to make one screen dot (see illustrations below).

An output device capable of 175lpi (that is, 175 lines of screen dots per inch) won't do you any good if there aren't enough pixels in your image with which to create all those nice round screen dots.

Similarly, a nice high-res digital image can never look its best when printed on a device whose LPI is too low to take advantage of the information in the file.

When our continuous-tone images are screened, they become what's called halftone images. Together, the line frequency of the halftone screen and the DPI fool our eyes into seeing a continuous-tone image.

Low-Res vs. High-Res

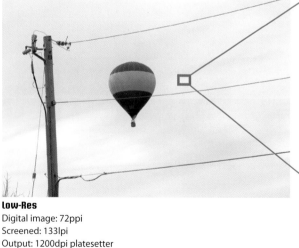

High-Res
Digital image: 300ppi
Screened: 133lpi
Output: 1200dpi platesetter

Screen Dots, Close Up
If we magnified the screen dots, they would look pretty close to round. Viewed normally, the dots look round and the image is satisfactory.

Low-Res
Digital image: 72ppi
Screened: 133lpi
Output: 1200dpi platesetter

Screen Dots, Close Up
When the image starts with too few pixels (here, 72ppi), there isn't enough information available to take advantage of all the dots available on the printer. The printer software can't build nice round screen dots out of coarse clumps of printer dots.

A Real-World Example

A typical magazine contains images scanned at 300ppi that will be output to either film or direct-to-plate at 1200 × 1200dpi, using a line screen of 133lpi.

Looking at those specs, you might wonder: Shouldn't the original art have been scanned at 1200ppi?

- For color art, the answer is no. The rule of thumb for color art is that PPI needs to be twice the line screen, or 2 × LPI = PPI. Our comic is being output at 133lpi, so even 266ppi would be acceptable. However, 300ppi is the industry standard for a hi-res image; it allows room for a little enlargement without sacrificing image quality.

- Line art is scanned at four times the line frequency, or 4 × LPI = PPI. The main reason for this is that solid black-and-white inked illustrations contain no gray values; everything is either 100% white or 100% black. No gray means there are no halftone dots to fool our eyes into seeing images as being smoother and softer than they really are. To compensate for this, line art needs to be scanned at a higher resolution to ensure optimum quality and detail.

Why Comics Break All the Rules

Comic books are special when it comes to resolution requirements because essentially you are trying to print a color image (ideal PPI = 2 × LPI) with a line-art drawing (ideal PPI = 4 × LPI) over the top of it. As a matter of fact, for years some comic and cartoon images were printed just that way—a 300ppi color file with a 600ppi line-art file laid over it in a layout application such as Adobe InDesign or Quark XPress.

With the rise of digital color, it was necessary to combine the color and the line art. If the line art were kept solid black and separate from the rest, we wouldn't have the glows and other special effects we take for granted today. A compromise was established within the comic book industry. While some publishers' PPI requirements vary, most professional comic colorists now color their files at 400ppi at 100% of finished size. This provides plenty of resolution for the color art and just enough extra resolution to keep the line art looking crisp.

What Determines LPI

LPI is determined by the surface being printed on. On an absorbent paper such as newsprint, dots of ink soak in and spread, so small, closely packed dots would tend to bleed together and result in a dark, muddy image. Smoother, less absorbent papers can

One Printer Dot
This is one printer dot, the smallest area the output device can turn on or off.

One Screen Dot
The output device creates each round screen dot out of many smaller square dots. A 1200dpi printer has 1200 printer dots per inch from which to build these larger, round screen dots.

One Printer Dot
The size of the printer's smallest possible dot hasn't changed. It's still a 1200dpi device. But this file contains too little information to take advantage of them.

One Mutant Screen Dot
This time, the screen dot isn't nearly as round, and the image quality is poor. The file doesn't contain enough information to control all the printer's dots individually, so it must lump the printer dots together to approximate the round shape of a screen dot.

handle higher line screens. So, for example:

- Newspapers are printed at 65 or 85lpi.
- A contemporary color comic book is printed at 133lpi.
- This book is printed at 175lpi.
- High-quality printing such as trading cards or art books can be as high as 200lpi.

The Most Common Scanning Mistake

All too often the first mistake people make is scanning their line art at too low a resolution. This practice can lead to artifacts in the image and really wreak havoc with the colorist, service bureau or printer. Scan your line art in at four times the linescreen (532) or the 600ppi standard in our case. Even though you will be resizing your scans for color, it is better to let your software resample a good scan than to never get a good scan in the first place.

Pro Tip Be Aware of Dot Gain

When a press puts down a dot of ink, the dot spreads to some degree as the ink soaks into the paper. This is called dot gain. The more absorbent the paper is, the greater the amount of dot gain.

For better reproduction on newsprint, you should take dot gain into account when specifying screen tones. In this example from *The Picture Taker*, Hi-Fi started with line art by Phil Hester and added screen tones of 20, 40 and 60% black. Knowing ahead of time that this comic was to be printed on newsprint, we purposely limited the darkest screen tone to 60%. Any darker, and dot gain could have caused the dots in the darkest screen to blend into each other and into the line art, making the images hard to decipher.

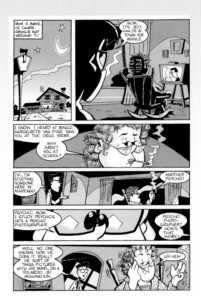

Pro Tip Scan Higher to Keep Your Options Open

Today, your comic strip might be headed only for screen viewing on the Web. Tomorrow, you might want to put it in print. If there's any chance you might one day need art for print use, scan it at a higher resolution and save a low-res version for the Web.

Resolution Standards for Comic Books

Here's what it all boils down to—recommended settings. We urge you to read the preceding pages in this chapter to understand *why* these are the recommended settings. But here's the information for quick reference when you need it.

- Inked art (line art): Bitmap mode, 600ppi at 100% size
- Pencilled art: Grayscale mode, 400ppi at 100% size
- Colored comic book pages: RGB mode, 400ppi at final print size, which is 6.875" × 10.438" (17.462cm × 26.512cm) for most U.S. comic books

Lines, Pixels and Dots, Oh-My!

When you understand LPI, you'll understand why the output from your laser or inkjet printer doesn't look as good as the same piece professionally printed. Most inkjets use a linescreen as low as 45lpi, and most laser printers top out at about 85lpi. So a laser or inkjet proof contains much less visual information (fineness of image, denseness of tone) than does a comic book professionally printed at 133lpi.

6.675" × 10.435" (17cm × 27cm) at 1200ppi: Too full; boxes won't fit on supermarket shelf.

6.675" × 10.435" (17cm × 27cm) at 400ppi: Just right.

6.675" × 10.435" (17cm × 27cm) at 72ppi: Contents have definitely settled during shipping.

Resolution: Not Too Little, Not Too Much

Imagine your comic book page as a cereal box, and resolution as flakes of cereal in the box. When you go to the store you want to buy a perfectly full box of flakes; you don't want one that's only half full, and you don't want one that's overpacked to the point of bursting.

The same is true of your comic book page. If it has too few pixels, the printer will be starving for information and the reader will be faced with a fuzzy printout rather than a sharp-looking one. If it has an unnecessarily high number of pixels, the printer will be stuffed with information and become lethargic leaving the reader waiting and waiting for the printout to arrive. If each comic book page is perfectly full of pixels, both the cravings of the printer and the reader will be satisfied.

Color Separations and Trapping

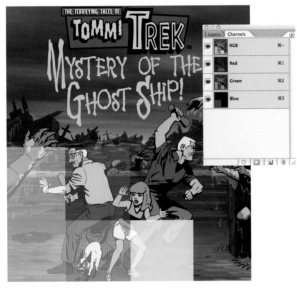

RGB Color
Computers use RGB to create color images on your screen and simulate CMYK color.

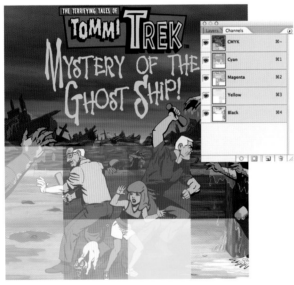

CMYK Color
Commercial printers use CMYK inks to create color composite images.

Pro Tip — Use Photoshop's CMYK Preview Mode

If you're preparing artwork for print, you need to know that some of the colors you see on a computer monitor are brighter and more saturated than what a printing press can achieve. For this reason, Photoshop has a feature called CMYK Preview. This setting allows Photoshop to display colors on the monitor in a manner more accurately than how they will reproduce on a printing press.

You are a super-talented artist, and you have mastered all the tips and tricks in this book. You meet up with an independent comic publisher at a local comic book convention who wants you to color a cover for their new series.

You color the art and the publisher loves it. The book gets printed and all your hard work is ruined when your reds look orangey and your blues lean toward green and everything else looks a bit muddy. The cover looked great on your screen. What went wrong? Is the printer to blame?

The above scenario is very common. Quite a few talented people have easy access to computers and image-editing software but few have a real understanding of the commercial printing process. Armed with a little knowledge, you can take your comic coloring beyond the computer screen and have much more confidence that your files will reproduce accurately.

What Is Color Separation?

As you learned earlier in this chapter, monitors and printing presses reproduce color in completely different ways. Your monitor uses red, green and blue light (RGB) to display images on its screen. A commercial press prints small halftone dots consisting of cyan, magenta, yellow and black inks (CMYK) to reproduce an image on paper. So before your RGB image can be printed, its colors must be converted to CMYK equivalents.

What Is Trapping?

One of the most important aspects of making good color separations is *trapping*. The large professional publishers will not accept digitally-colored files unless they have proper trapping and undercolor.

Preview: Hi-Fi Color Separation Actions

If you use Photoshop, you might be wondering: Can I simply use Image > Mode > CMYK in Photoshop to convert my images?

You could, but no professional colorist would recommend it. As a colorist, you need to take many factors into consideration when making your color separations, including the paper stock your art will be printed on and the printer's specifications for things such as maximum ink density and trapping. Luckily Hi-Fi has automated much of this process for you, as we'll explain shortly (on page 142).

The inks used in the CMYK printing process are transparent. This means each ink allows the color of any ink printed beneath it to show through. Even the black ink is transparent. So the solid black areas of your image must be trapped, which means creating an area of gray color made from the CMY inks underneath the black ink.

This is called "trapping" because the gray color made from C, M and Y does not extend beyond the edges of the black areas. In other words, the gray color is trapped by the black.

The gray color is called the *undercolor* because it lies underneath the black. You will also hear this referred to as "backing up the black" or "creating a rich black."

So if a printing company's specifications state "4-pixel trap with undercolor max 240," that means the gray color should be constrained 4 pixels inside the solid black areas, and the maximum ink density of the undercolor plus the black must not exceed 240%. This is currently the most common print specification for comic books.

Don't worry if some of this sounds complicated. You will see in the following pages that Hi-Fi has made the separation and trapping processes virtually pain-free.

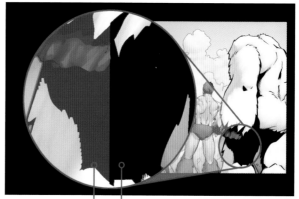

CMY CMYK

Image With Correct Trapping
The CMY gray undercolor sits 4 pixels inside and beneath the black line art, "backing up" the black. The gray is made up of 60% cyan, 40% magenta and 40% yellow. Add 100% black and you have 240% maximum ink density.

Pro Tip Work Under Consistent Light

The more consistent the lighting in your workspace, the more consistent your colors will be. Use blinds or curtains to control the ambient lighting. Keep harsh direct light away from your computer monitor; use indirect lighting.

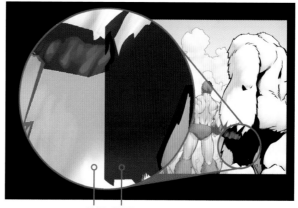

CMY CMYK

Image Without Trapping
Without trapping, the areas where two colors meet underneath the line art show through, ruining the look of the artwork.

Color Separation With the Hi-Fi Step 3 Script

Congratulations! You have made it to Step 3. Your page has been matted and rendered, and you may have added color holds and special effects. Now you are finally ready to translate your RGB color file into a glorious CMYK color separation. Follow the steps in this section to create your color separation that's ready to be printed on your own color printer or to be output on a commercial printing press.

1 Check the Layers

Before you run the Hi-Fi Step 3 script, always be sure your Layers palette looks like one of these two examples, or the resulting CMYK file will not be correct.

For example, if you have a Holds layer or any other extra layers, merge them into the Background layer now (Command-E [PC: Ctrl-E]).

2 Check the Channels

Go to your Channels palette and make sure your list of channels matches our example. In addition to the normal Red, Green, Blue and RGB composite channels, you should have a Line-Art channel and a Flats channel. Delete any other channels you may have made.

3 Check the Color Settings

Unless your editor or printer provided you with different color specifications, check your color settings to ensure the Hi-Fi color settings you loaded earlier (see page 11) are still active. (The Hi-Fi color settings should remain active unless you change them; however, it is possible to accidentally reset or overwrite them. To be safe, we recommend regularly checking that the proper color settings are active.)

4 Save the Final RGB Version, Then Save a New Version for Separating

Save your final RGB file one last time. Then re-save this file under a new name using File menu > Save As. That way you can always return to your final RGB file to make changes or corrections if needed.

5 Run the Script

Choose File menu > Scripts > Hi-Fi Step 3. In the dialog box that appears, you have the choice of making a color separation with or without special effects. Check your Layers palette—do you have a Special Effects layer? If so, choose to make a color separation with special effects. If not, choose to make a separation without special effects. When you're satisfied with your settings, click OK to run the script. Do not touch any keys, click any tools or switch to any other application while the script runs.

If you accidentally choose the wrong type of color separation, don't panic. Let the script run until it fails. Then close the page without saving. Now, open your final RGB file again and run the correct type of color separation.

6 Save

When the script is finished running, you should save your file as a TIFF. To ensure you do not save over any of your previous work files add the suffix "_CMYK". For example, a working file named Tommi Trek 5_14_400_C.psd will become TommiTrek 5_14_400_CMYK.tif. Unless your publisher or printer has supplied you with different guidelines, enable LZW compression in the TIFF Options dialog box. This will make the file smaller and therefore faster to upload to an FTP server or to backup to a hard drive, CD or DVD.

You now have a color-separated, trapped and print-ready CMYK file.

Examples of Good and Bad Separations

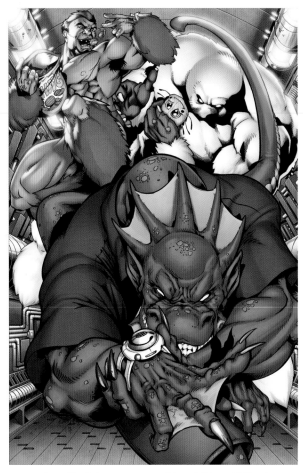

Good Trapping: Gray Color Backing Up the Black

In this example the color has been lightened and the black made more transparent, allowing you to see through into the trap. The trapped area is a solid gray color underneath the black made up of C60/M40/Y40/K00 (the line art is 100K). If you look at the heavy shadows between Loch Mo's shoulder and his ear you can see the trapped area just inside the line art. The trap backs up the solid black areas and keeps any stray color from peeking through.

A page from *The Enigmas* separated from RGB to CMYK color with trapping.

Bad Trapping: Color Areas Under the Black Line Art

In this example the black has also been made more transparent—and what do you see? No trap. Notice the areas of the flats you can now see. Look at Loch Mo's ear on the left of the page where the green runs into his shoulder. What about the green areas under his chin? The shadow is nearly gone. This gives you some idea of what could happen if you were to print a page that was not trapped correctly. The results are not pretty.

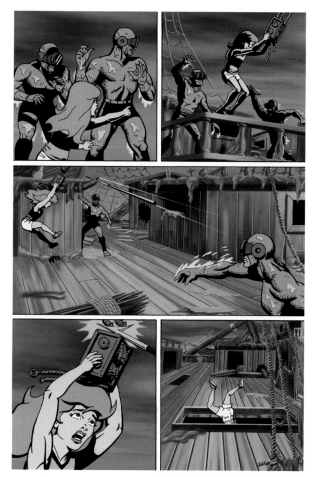

A page from *The Terrifying Tales of Tommi Trek* separated from RGB to CMYK color with trapping.

No Trapping: Black Color Has Knocked Out CMY Channels

Some image-editing software automatically knocks out the color underneath solid black areas. If you were to turn off the black channel and look only at the CMY channels, you would see white underneath the solid black areas. This technique does eliminate the issue of seeing through the black to colors underneath (as in the bad trapping example from the previous page). But this technique has a few drawbacks.

CMY Knockout + Plate Shift = Disaster

Using the technique where the black knocks out the CMY beneath can cause some disastrous problems when printing. The first problem is that if the press is out of register (the CMYK plates are not perfectly aligned at all times), you can get white "ghosts" in your images when printed. This is caused by the black plate registration being slightly off allowing some of the white to show through.

The second problem with the knockout technique is the black is printed 100K with no gray value to back it up. Because printing ink is transparent, the black ink prints over the white and looks dull and not as rich. Compare this example to the main image and you will notice the difference in the black areas.

CHAPTER SEVEN

Making It as a Professional Colorist

Introduction by Jim McLauchlin, President, The Hero Initiative

The freelance lifestyle has its ups and downs. On the upside, you can work at home in your underpants, and while Joe Nine-to-Five is slugging it out on the interstate, your notion of a traffic jam is when your dog is lying at the top of the stairs. On the downside, freelancing requires enormous fiscal discipline. (But is that really a downside?)

When I'm working freelance, I religiously sock away 30 to 35 percent of every check I get so that I can cover the eventual and dreaded income tax. Does it hurt? Yeah. Does it sometimes feel as if I'm working for almost nothing? Yeah. But it's necessary. Lo and behold, I've found that when I stick to this regimen, after all those delicious deductions, I end up owing a lot less than what I socked away. It's like getting a tax refund from myself—and I've been earning interest on it.

So, that said, yeah—business of comics? Save all receipts, because everything's a deduction! If you use jobbers or subcontractors, make sure you get a W9 from them. And so on.

The good news: Today there are resources such as this book to teach you the steps. In the good ol' days . . . not so much. Which is why the Hero Initiative (www.heroinitiative.org) exists. The Hero Initiative is the first ever federally chartered not-for-profit dedicated to helping comic book creators in need. Hero creates a financial safety net for yesterday's creators who may need emergency medical aid, financial support for essentials of life, or an avenue back into paying work. It's a chance for all of us to give something back to the people who have given us so much enjoyment.

Did I mention you can deduct your donation? Feel free to check out the website and send us a couple of bucks. Start saving on those taxes today.

TORONTO COMIC CON GUEST OF HONOR PRINT, 2007
Art by Terry Moore & Matt Wagner
Commissioned by Jim McLauchlin
Color by Hi-Fi

Identifying Your Direction and Finding Clients

Getting Organized and Creating a Portfolio

Before you seek new business, you need to ask yourself what you want to do with your coloring skills.

You may have discovered that you like coloring comic book art and that you're pretty good at it, too. If this describes you, then you might already be wondering how you can take your new skills and break into the comic book business.

The first step is to color as much artwork as you can get your hands on. There is some terrific black-and-white line art on the CD-ROM included with this book. There are also several sites on the Internet where you can download artwork to color.

Perform a Web search for "comic colorist forum" and you will find the most popular sites for comic book colorists. Many of these websites allow you to post your colored images for review by other members of the coloring community. It can sting a little to get your first critique, but you will quickly find that most colorists are willing to provide you with positive and constructive criticism to help you hone your skills and refine your craft.

Once you have colored several pieces, you can think about creating a portfolio of your work. Pick your best *eight* pieces, no more. Choose a good mix of pin-ups and sequential pages that show off your visual storytelling skills.

Print your top eight in color on nice paper. Buy a leather artist's portfolio to showcase your work, or at least put the pieces in a binder. The point is not to have loose printouts that can become lost or damaged. Presentation counts!

You can also create an online portfolio using any of the popular social networking websites. There are many web communities out there, specifically for comic artists and colorists, where you can showcase your talent.

Meeting People and Making Contacts

You have made a nice portfolio. Who are you going to show it to?

If you have an online portfolio, you've probably discovered other artists online, too. This is a good way to start building relationships with other talented individuals interested in comics. However, it's no substitute for getting out and making face-to-face contact with real people. Find out if your local comic book shop has a place in their store where they feature local talent. Maybe there is an annual comic book convention near you, or maybe you can make it to one of the large national conventions.

A comic book convention is most likely the best place to start making friends in the industry. Take your portfolio and offer to show it to everyone in Artist's Alley and all the publishers, whether big or small. Don't even worry about trying to find work coloring; just show people your portfolio, listen to what they have to say, and take their business card if they have one.

Though you may not absolutely need business cards, a commercially printed or homemade contact card is always appreciated. Your card should have your name, a way to contact you, and if you are a penciller, inker or colorist. This will help them remember you when you follow up with them after the convention.

Did you listen to the feedback people were giving you at the con? Did you really listen? Good. Be sure to ask about what they are doing at the convention as well. Anyone sitting at a table in Artist's Alley or selling their comics from a larger booth probably paid big bucks just to be there; they will appreciate your interest in their work, too. Who knows—you might find out you share a common interest or two.

The point is this: If you go looking for work you will probably come across like a used-car salesman, and no one likes that. If you go looking to make real, honest connections with people, you will start to build relationships within the comic community that may last a lifetime. Do what you can to help out your friends in the comic industry, and you will find your goodwill is returned to you tenfold.

Do not be too stiff or businesslike at comic conventions. Comic books conventions are fairly laid-back events. Take time to meet other creators, sit in on some interesting panels, check out the costume contest, and just have fun.

Business Card
Be ready to offer publishers, editors and other creative professionals your business card so they can stay in touch with you.

If you are not having fun at a comic con, you're doing something wrong!

After the convention, sort through all the business cards, sketches, comics books and swag and make a list of who you need to follow up with. Do all of your follow-up within ten days after the convention.

Divide your list of follow-ups into two columns: people to drop a casual email to, and people to whom you should send something.

For the latter, be sure to send a cover note (either typed or handwritten is OK), a copy of each image from your portfolio (include your contact info on the front or back of each piece), and a contact card. If you are sending a package to one of the larger publishers, spend the money to send it by overnight carrier. This is a good way to guarantee your package will actually make it to the person you want to follow up with and make sure it doesn't get lost amid the daily mail stack.

If you do not hear from someone to whom you sent a package, you may feel the urge to call them. One follow-up phone call is considered acceptable. Multiple calls will inconvenience the person whose favor you are courting and make you appear to be a pest.

Portfolio
When thinking about which images to include in your portfolio be sure to include a variety of your best work.

Illustration © 2007 Mike Worley, color by HiFi

Conventions and Portfolio Reviews
Attend comic book conventions to build relationships in the industry and gain valuable feedback on your work

Roles in the Comics Industry

It feels a bit like graduation day; you have learned so much and come so far! You can now flat and render a comic book page, make color holds, add special effects and even create final color separations. Your story doesn't end here. What you choose to do with these new skills can permanently change your life. This section will give you some idea about what you can expect to find in the real world when you seek outlets for your *Hi-Fi Color for Comics* skill set.

Coloring Jobs

Flatter

The number one way to break into the business is flatting for other colorists. If you're fast as well as good, you can flat for multiple colorists. It's also a great way to stockpile art upon which to practice your rendering skills. (Just remember that any artwork you practice on that doesn't belong to you must never leave your studio.)

Background Colorist

Some flatters, with practice, end up rendering backgrounds for the colorists they work for. This is a good way to hone your rendering and lighting skills and to learn how to collaborate.

Assistant Colorist

Usually a freelancer, the assistant colorist works for another colorist or a color studio, helping other colorists meet deadlines. This is a terrific opportunity akin to an apprenticeship. You'll get direct experience on big projects that otherwise would take you years to work your way up to.

Freelance Colorist

Freelance colorists color pages directly for a publisher. They usually have several freelance flatters working for them.

Freelancing allows the colorist to work from home, set his or her own hours, and exert full control over every project and all aspects of the business. Most colorists in the comic book industry are freelance colorists.

Studio Colorist

A colorist who works in a real or virtual studio with other colorists. To thrive in this role, you must be a team player.

Studios offer several benefits for clients. High quality is easier to achieve when multiple people are lending their talents to a project. Multiple colorists working together can finish a project faster than a solo colorist. Studios typically have a staffer who manages workflow and business details, which means clients get better service and the colorists can focus on being creative.

Contract Colorist

This rare breed of colorist has a contract with one publisher that guarantees a certain amount of work each month in exchange for exclusivity. A freelancer, who is able to work for anyone, might work more and earn more than a contractor. But for some, contract work is a dream job because the income is guaranteed.

Types of Clients

Comic Book Publisher

An editor gives you art, a script and a deadline, which is generally about ten days to color a typical twenty-two page comic book. You're also responsible for researching mainstream character colors and costumes and for going through one round of corrections and changes. That's quite a bit of pressure, especially since the colorist is the last person in the art "assembly line." If the writer, penciller or inker is late, there's no time left for the colorist.

Book Publisher

An editor or creative director works with you to design the color look for a series of book illustrations. Expect multiple rounds of corrections and changes because many people at the publishing company weigh-in their input. Most book projects last up to six months; some require you to hire and work via a literary agent.

Toy Company

Toy companies often need artwork colored for pitch meetings, packaging, and promotional items. You work with a creative director on a project-by-project basis.

Magazine Publisher

You work with a creative director to color an illustration. Magazines usually like to hire a pencil-and-color team, so either sharpen your pencils or make friends with a gifted artist.

Syndicate

An art director will give you pieces of comic strip art to color, usually in a simple manner, for school supplies, apparel and souvenir items. This work is usually seasonal.

Other Entertainment Companies

Video game makers, film studios and record labels occasionally need coloring work too. It's good work if you can find it.

The Financial Side

Invoices

To get paid for your freelance work, you must submit an invoice, or bill, to the client. You may also be required to submit an invoice if you work for a color studio.

The payer will probably specify how they want invoices from you, everything from address to layout requirements. If you don't bill the client correctly, they either can't pay you or your payment will take longer.

Some of the people in the comic creation process get paid upfront or in installments; unfortunately, colorists are not among them. Normally you'll submit your invoice along with the completed work. Clients' payment terms vary anywhere from Net 15 (payment fifteen days from receipt of invoice) to Net 45. Most of the larger publishers need thirty to forty-five days to process the paperwork and pay you. You can see how important it is for colorists to plan ahead.

If you're working for a smaller or indie publisher, you can often negotiate your terms up front. You might suggest to a new client that they pay half upfront and half upon completion of the project. After perhaps three projects, the client can switch to paying Net 15; and eventually, if they remain in good standing, to Net 30.

As soon as you start working with a new client, it's good policy to ask what their payment schedule is. You should be able to get that information either from your editorial contact or from someone in the accounting department. Don't fear that you will appear rude for asking; you're a businessperson. You're better off expecting and receiving payment in thirty days than counting on it in fifteen days and being disappointed.

Every invoice should include:

A unique invoice number. Some companies will even want the invoice number to be a certain length or a certain mix of letters and numbers.

Your name and address. This way the client doesn't have to look up your information and possibly get it wrong, which could delay your payment.

Your Social Security Number or Tax ID Number (most likely). Ask whether the client needs your SSN with each invoice, or just the first one. Once they record your SSN in their payment system, they may not need it repeated on every invoice. If you can minimize the number of pieces of paper flying around with your SSN on them, you reduce the chances of such information falling into the wrong hands.

The invoice date. Make the date on the invoice the same as the day you mail or deliver it to your client.

The name of the project, what type of work you did and how many pages you submitted. Example: "Birds of Prey, digital coloring for 22 pages."

The per-page price and the total. The per-page price will vary from publisher to publisher and even project to project.

On the CD-ROM in the folder named "Bonus Art," you'll find a couple of sample invoices (Client_Invoice.pdf and Freelance_Invoice.pdf).

Keep a copy of every invoice you send out so that you can resubmit in the event the original gets lost in the mail. If you become really busy, you may want to invest in a bookkeeping

Hi-Fi colour design, LLC
14929 W. Lisbon Ln.
Surprise, AZ 85379

Invoice

DATE	INVOICE #
07/30/07	1268HF

BILL TO:

DC Comics
1700 Broadway
New York, NY 10019

P.O. NUMBER	TERMS	PROJECT
	Net 30	CTDWN #36

QUANTITY	DESCRIPTION	RATE	AMOUNT
22	Digital Color Service	0.00	0.00
	Delivery via FTP	0.00	0.00
	Please make check(s) payable to: Hi-Fi colour design, LLC	0.00	0.00
		TOTAL	$0.00

Sample Client Invoice

system that will generate and keep track of invoices for you (such as QuickBooks or Quicken).

It's hard for the small business owner or freelancer to accept payment by credit or debit card. The machines and systems are too expensive for anyone who would use them on an infrequent basis. However, with the innovation of PayPal and the increasing availability of wire transfers though banks, you do have other options. Keep in mind that PayPal and wire services both charge fees, so if you bill $300, in actuality you're receiving a bit less.

Employee vs. Freelancer

There's a difference between being an employee of a company vs. a freelancer (also known as a contract laborer or a 1099, the tax form given to free-lancers). If you're an employee, the company offers you valuable benefits (packages vary, but they could include health insurance or stock options). The company also pays some of its employees' taxes. The taxes come out before the employee ever sees the check.

As a colorist you typically will work as a freelancer rather than an employee. That means you are responsible for your own insurance and taxes. That's a big chunk, and it should factor in to the rates you charge as well as your savings habits. If you keep on top of your tax situation, you will be fine at the end of the year; if you procrastinate on the tax issue or ignore it, the IRS man will show up at your door. Consult a professional adviser to avoid such a scenario.

You might receive statements of your freelance income only once a year, yet you may need to pay your taxes quarterly, so it is up to you (through your invoices and other records) to keep track of how much money you are making. This one issue causes many people to either shy away from freelancing or to get themselves into financial trouble with the IRS. A tax professional can help you prepare for the day your tax bills are due.

Keep in mind that this all changes when you become so popular you have to hire people to help you. Hi-Fi has had as few as four employees and as many as thirty-five contractors at a time. Whether you decide to open a studio or just plan to get your buddies to help you with projects, be sure to consult a professional so you know what your tax obligations are.

John Smith

123 Anywhere Rd.
Springfield, AZ 12345
USA

Phone: 555-555-5555
Fax: 555-555-5555
Email: xyz@example.com
Website: www.example.com

Invoice

Invoice #:	001
Invoice Date:	08/08/08
SS#	123-45-678

Bill To:
Hi-Fi colour design
Surprise, AZ 85379

Quantity	Item	Units	Description	Unit Price	Total
2	Flats	12, 13	BoP 109	$00.00	$00.00
5	Flats	1-5	Enigmas 1	$00.00	$00.00
6	Flats	9-14	Countdown 31	$00.00	$00.00
4	Flats	2-3, 8, 9	Shrek	$00.00	$00.00
2	Backgrounds	5, 7	New X-Men 477	$00.00	$00.00
1	Cover	Rush fee	Star Trek: TOS 5	$00.00	$00.00
				Subtotal	
				Balance Due	$000.00

REMITTANCE
Customer ID:
Date: 8/6/07
Amount Due:
Amount Enclosed:

Sample Freelance Invoice

152

Your Responsibilities

While there is a lot of fun to be had working in comics, there's also a fair share of responsibility. You know best what you're capable of and what sort of personality and professional discipline you have, so weigh your responsibilities before rushing head-long into comics.

Make All Your Deadlines

This is the big one. If you cannot motivate yourself to stay on top of your pages and meet your deadlines, do not even bother thinking of becoming a colorist. A missed deadline will usually result in no more work from that editor or publisher. While freelancing from your home may sound like a dream job, "setting your own hours" often means working days, nights and weekends to get a project finished on time.

Respect Others in the Industry

The comic book world is very small. The guy with the self-published comic book that you are rude to at a convention today might become the editor who decides whether or not you get a coloring gig at the large publisher tomorrow. Treat everyone in comics with respect and dignity; burned bridges are tough to rebuild. Work long and hard at coloring, and you will earn the respect of others in the industry as well.

Appreciate the Kindness of Others

Flatting or rendering backgrounds for an established colorist can go to your head quickly. When you start getting pages with those big-time superheroes on them, you feel like a big shot yourself. Remember that the colorists you are working for spent years building relationships and working up to the projects they have now. They are giving you an opportunity to help out on titles you could not have landed on your own. The work is coming through them and it is their reputation on the line if you screw up. Appreciate the opportunities you are given, learn all you can from your mentor colorist, and repay them with fast, accurate, impassioned work on each and every project they choose to give you. Your humility and service will be repaid with bigger and better opportunities.

Illustration © 2007 Mike Worley, colors by HiFi

Appendix 1:
A History of Comic Book Coloring

The First Colorists

The earliest printing was done with carved blocks of either wood or stone. During the Han Dynasty in China (206 B.C.–220 A.D.), artists printed flowers on silk using woodblock printing in multiple colors. Egyptians began printing on paper around the sixth century.

The Technical Challenge of Multicolor Printing

Aside from the labor of carving the block, the act of block-printing a single impression was pretty simple. Multi-color printing was more challenging and took longer to develop. That's because with any type of color printing, there's a separate block or plate for each color, and all the impressions have to register (align) properly or the final image won't look right.

The story of comic coloring, therefore, is largely the story of how technology improved to permit the kind of color reproduction we enjoy today.

Block Printing Innovations

For hundreds of years, printing continued to be done with carved blocks. German and Italian artists in the 1500s and 1600s developed ways of printing quite detailed woodcut images in multiple colors. In 1508, German artist Hans Burgkmair created "chiaroscuro woodcuts"—woodblock prints in which the dark lines were printed with one block, while areas of flat color were printed with another block called the "tone block."

But before humankind could enjoy mass-produced comics, it had to wait for the invention of mass production for comics.

Enter Mass Production

The first means of color printing in high quantity was chromolithography, which arrived in the U.S. around 1840. For each color (up to two dozen of them), an image was drawn onto a limestone plate with a greasy black crayon. The stone was then wetted with water, followed by an application of oil-based ink. The greasy ink stuck only to the greasy drawing on the plate, which was then pressed onto paper.

Printing technology improved in the nineteenth and early twentieth centuries. The rotary press (1843) made printing faster because it allowed paper to be fed into the press continuously, from a roll, instead of sheet by sheet. The offset printing process (1903) heralded a new era of print quality. In the offset process, the image is transferred from the plate cylinder to a rubber cylinder,

COVER, *BIG BANG* #31
Published by Image Comics
Traditionally colored by Mike Worley using percentages of CMYK

then to the paper. The rubber blanket conforms better than a metal plate to the texture of the paper, creating a cleaner impression.

The Comic Art Form

Enough about printing, for the moment. What about comics?

The Yellow Kid is generally hailed as the first popular comic strip character. He appeared in Joseph Pulitzer's *New York World* and William Randolph Hearst's *New York American* beginning in 1895. More comics emerged in the next few decades. In 1922, King Features debuted *Comics Monthly*, each issue of which was devoted to a different comic strip character. In 1929, New Fiction Company published *The Funnies* #1. This book, later hailed as the original four-color comic publication, was sold at newsstands for ten cents.

Comics had achieved unprecedented popularity by the 1940s, but comic coloring was rudimentary compared to the art form it is today. The papers and presses of the time didn't permit much subtlety in color variations. Printers could do 25%, 50% and 100% screens of cyan, magenta and yellow; all the possible combinations of those yielded a palette of just 64 colors. Due to the expensive high-tech equipment needed to produce four-color plates, the color separations took place behind the scenes. Usually the separator was provided with a painted version of the page called a color guide. Other times a code was written on the art to tell the color separator what percentage of each color to use. In fact, sometimes the printer, rather than the artist, chose the colors.

Comic colorists began to step into the limelight in the mid-1960s, when publishers slowly began including the colorist in the list of credits on the title page of each book. For the first time, readers became aware of the talented people behind the coloring. As colorists were given more and more freedom to create, the color separators had to invent new ways to produce mechanical color separations that

resembled the ever higher-quality coloring work. Some separators began experimenting with litho markers, airbrush techniques and xerography as a way to push the boundaries of mechanical color reproduction.

By the mid-1980s, some comic colorists, such as Adrienne Roy, Roy G. Biv (a pseudonym based on the colors of the rainbow; real name unknown), and Lynn Varley were becoming well-known enough to have their own fan followings. While comic colors were still primarily flat, these colorists and

others like them were raising the bar when it came to using color theory and incorporating mood with light and shadow into their storytelling. For many comic book fans, Lynn Varley's colors on Frank Miller's *Batman: The Dark Knight Returns*, published by DC Comics in 1986, marks the pinnacle of pre-digital coloring.

Digital Color

In 1988, a colorist named Steve Oliff put digital coloring on the map and on publishers' radar for the first time.

Spider-Man™ ©2007 Marvel Characters, Inc. Used with permission.

Steve colored the U.S. debut of the Japanese manga *Akira* for Marvel's Epic imprint, using proprietary hardware and software. When comic fans looked upon *Akira* for the first time, they realized they were seeing something wonderful and new. *Akira* marked the first time anyone had seen digital color gradients published in comics, as opposed to the standard flat color. And since Steve was initially the only one who knew how to work the hardware and software, he was both colorist and color separator. Steve went on to win a Harvey Award in 1990 for his work on *Akira*.

Publishers were not quick to jump aboard the digital coloring bandwagon. Early digital color was slow, expensive and not always reliable. The specialized hardware and software meant that one colorists' files might be incompatible with someone else's, or, worse yet, incompatible with the printers' systems.

In 1992, Steve Oliff's digital color studio, Olyoptics, colored the first issue of Todd McFarlane's *Spawn*. Since Olyoptics wasn't constrained by the normal budgetary and deadline concerns of the big two comic publishers, Oliff was able to push the digital techniques begun with *Akira* into a new realm of gradations, rendering, color holds and glows that many had never witnessed before. *Spawn* was also distinctive for being printed on high-quality paper, which allowed for a broader range of contrast and depth within the coloring.

In 1994 the Apple Macintosh desktop computer had emerged after a decade of evolution as a desktop publishing powerhouse. Around the same time, Adobe Photoshop had grown from a scanner utility into a full-featured image editor. It didn't take colorists long to realize the potential of these off-the-shelf products. The same year, Wildstorm FX began digitally coloring and separating J. Scott Campbell's *Gen¹³* using Photoshop. A new era in digital color began as specialized hardware and software were no longer needed to color and separate comic book artwork.

As the cost for computer hardware and software decreased, the large

COVER IMAGE, *STRANGERS IN PARADISE* VOL. 3 #85
Art by Terry Moore
Color by Hi-Fi

publishers began working with individuals and studios to have their color separations made digitally. Most of these publishers still used hand-painted color guides or the old system of codes to specify which percentages of colors should be used. Eventually the mechanical color separation process was long forgotten as one by one the publishers converted to digital.

With the publishers finally on board, some colorists stopped painting color guides altogether and started working directly on the artwork in Photoshop.

Elsewhere, digital separators had become so proficient at using the software that in many cases they became the new generation of colorists. By the year 2000, the concept of colorist and separator as two jobs (completed by two individuals) had vanished completely. For the new millennium, the colorist was capable of visualizing the colored page, rendering the colors in Photoshop, and making her own digital separations ready for the publisher and printer. No wood blocks, grease crayons or litho markers required.

Glossary

Anti-aliasing: A form of smoothing accomplished by lightening pixels at the edge of a shape.

Atmospheric perspective: The phenomenon in which objects appear lighter, lower in contrast and less detailed the more distant they are.

Base cut: The first *cut* you make when you start rendering a comic art subject.

Bitmap: The color mode used for scanning *line art.*

Bleed: An extra margin of colored image beyond the final page edge to ensure that color extends all the way to the edge after the book is trimmed.

Channels: A kind of "container," separate from the RGB part of an image file, that can hold any image containing up to 256 shades of gray. Useful for storing selections and for protecting line art from accidental alteration.

CMYK: The method used to reproduce color artwork on a printing press, named for the four ink colors used: cyan, magenta, yellow and black.

Color hold: An area of line art that has been changed to a color other than black.

Color separations: Print-ready files created by "separating" an RGB file's colors into cyan, magenta, yellow and black (*CMYK*).

Color temperature: How warm (yellowish) or cool (bluish) a color is. Cooler colors appear to recede into the picture, while warmer ones advance.

Continuity: In coloring, the logical consistency of color choices from panel to panel or from book to book.

Core highlight cut: The brightest center highlight in a rendered area, often used to attract the eye to important parts of a composition.

Cropping: The act of cutting away image area at one or more edges.

Cut: An area selected for rendering; also, the completed rendered selection.

Cut and brush; cut and grad: Making a selection in a digital file then painting within it using either the Brush or Gradient tools.

DPI: Dots per inch; a measure of the *resolution* of output devices such as printers.

Flatting: Creating flat color fills in a piece of digital comic art. This is the first coloring step.

Gamut: The range of colors that can be reproduced using a given reproduction method. The RGB gamut is mostly wider than the CMYK gamut, so some colors that look great on a monitor can't be duplicated on a press.

Gradient: A digital painting tool that creates a smooth, even transition from one color to another.

Grayscale: An image made up of black, white and shades of gray only.

Halftone: An image screened into dots of different colored inks that can be printed. The smaller the halftone dots, the smoother the image appears.

JPG: A file format that uses *lossy* compression (meaning some image quality is sacrificed to reduce file size).

Line art: Art that consists only of solid black and pure white, with no shades of gray.

Line screen; line frequency: The density of the grid of dots in a *halftone* screen, measured in *lines per inch.*

LPI: Lines per inch; describes the density of the halftone screen of which an output device is capable.

LZW compression: A form of file compression available for TIFFs that is lossless, meaning no image quality is sacrificed to achieve a smaller file size.

Maximum ink density: The maximum total of C, M, Y and K screen percentages that a printing press can handle. For comics, generally 240%.

Pixel: The smallest controllable spot in a digital image or a computer monitor.

PPI: Pixels per inch; the measurement of resolution of a digital image or computer monitor.

Reference: Guidance on color choices for comic art, whether in the form of a character chart or simple notes.

Rendering: Adding shading and highlights

on a two-dimensional image to create the illusion of three-dimensional form.

Resolution: The fineness of a digital or printed image, measured in terms of how many pixels or dots are squeezed into a given linear measurement.

RGB: The method used to reproduce colors on a computer screen or television, named for the three colors of light used: red, green and blue.

Rim lights: A highlight *cut* that is added immediately adjacent to the edge of an object being rendered.

Safe area; live area: The interior zone of a printed page; the area that is far enough from the edges to be considered safe from trimming during the binding process.

Scaling: Changing an image's size.

Screen dots: The grid of dots used in a *halftone.* The impression of lighter or darker shades is created by varying the size of the dots.

Secondary cut: The second, lighter rendering cut that is made after the *base cut.*

Selection: An area of a digital image that has been outlined with a selection tool so that color changes can be performed on it.

Stitching: Piecing together two scanned page halves to create a seamless full page.

TIFF: A file format that can be black and white, grayscale or color. *LZW compression* can reduce the file size of a TIFF without loss of image quality.

Trapping: Since no printing process is 100% accurate, a method is needed to compensate for registration shifts. Trapping allows a slight overlap of colors to prevent unprinted paper from showing in the final printed product when slight registration problems occur.

Index

Master comic art with these great titles from IMPACT!

ISBN-13: 978-1-58180-758-5
ISBN-10: 1-58180-758-9
Paperback w/CD-ROM, 144 pages, #33425

Supercharge your drawings with the power of photo reference! Learn to capture accurate lighting, foreshortening and body language in your drawings with Buddy Scalera's ultimate photo reference tool. This book and CD-ROM set features over 1,000 high-quality color photos of dynamic poses and complex body mechanics created especially for aspiring or professional comic artists.

ISBN-13: 978-1-58180-985-5
ISBN-10: 1-58180-985-9
Paperback, 128 pages, #Z0842

Learn to create Original English Language (OEL) manga comics and graphic novels using classic manga techniques. Aspiring beginner artists will benefit from Colleen Doran's insider tips such as how to create a cover, how to develop an authentic style, and how to get published. Also learn how top manga artists collaborate to produce over 100 pages of finished art each month.

ISBN-13: 978-1-58180-852-0
ISBN-10: 1-58180-852-6
Paperback, 128 pages, #Z0055

Experience immediate success drawing fantasy-style characters with Jessica "NeonDragon" Peffer's in-depth, step-by-step instruction. In her follow-up project to the wildly popular *DragonArt: How to Draw Dragons and Fantasy Creatures*, Peffer shows you how to create complete color illustrations of basic and complex characters such as elves, orcs, goblins, merfok, fauns, centaurs, werewolves, vampires and more!

These books and other fine IMPACT titles are available at your local fine art retailer, bookstore or online supplier or visit our website at www.impact-books.com.

About the CD-ROM

Hi-Fi Color for Comics includes a book supplement that's loaded with extras to start you coloring faster and better!

EASY TO USE—MAC AND PC COMPATIBLE

Includes

- Art files for all step-by-step demos and homework lessons
- Photoshop presets for palettes, brushes, scripts and actions
- Professionally drawn bonus art for practice
- Hi-Fi Helpers for white-hot special effects and subjects such as grass, fire and snow
- Sample color separations with trapping